CREATIVE
COLORED
PENCIL

Easy & Innovative Techniques for Beautiful Painting

Gary Greene

NORTH LIGHT BOOKS

Cincinnati, Ohio
ArtistsNetwork.com

Contents

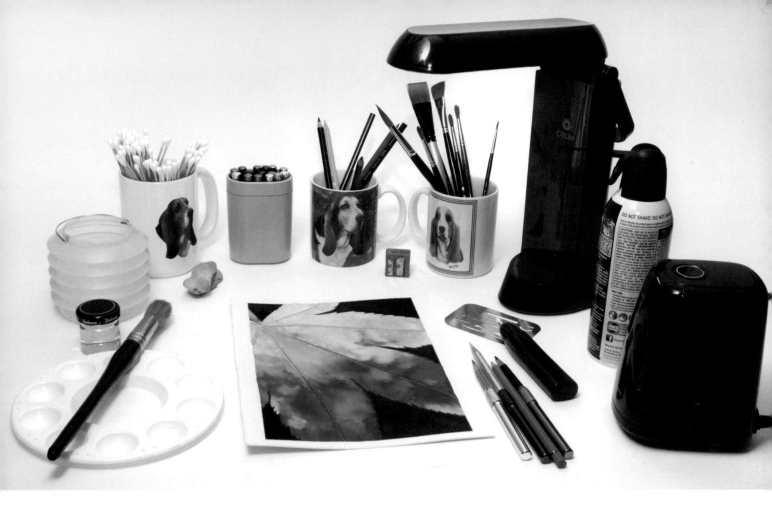

TOOLS AND MATERIALS USED IN THIS BOOK

SURFACES

Fabriano 300-lb. (640gsm) soft-pressed watercolor paper

Arches 300-lb. (640gsm) rough water-color paper

Strathmore Series 500 bristol vellum 3 ply, regular surface

Strathmore or Rising 4-ply black museum board

SUPPLIES

Watercolor brushes: large flat, medium flat, small flat, medium round, small round, small synthetic round, small synthetic flat, small fine-tip round

Bestine rubber cement thinner

Turpenoid colorless turpentine

Mineral spirits

Vodka

Ronsonol Lighter Fluid

Isopropyl (rubbing) alcohol

Prismacolor Colorless Blender Pencil

Cotton-tipped applicators

Cotton-tipped makeup applicators

Cotton balls

Winsor & Newton Colourless Art Masking Fluid

Small battery-operated eraser with vinyl strips

Electric eraser with a coarse ink eraser strip

Erasing shield

Kneaded eraser

Abrasive ink eraser

Plastic watercolor palette

Water containers

Fine-mist atomizer

Fine-mist spray bottle

Eyedropper

Tweezers

Emery board

Paper towels

Small glass container

No. 11 craft knife blades

White gesso

1-inch (3cm) Scotch removable tape

Burnisher

Circle template

Small plastic straightedge

COLORED PENCILS

Faber-Castell Albrecht Dürer

Faber-Castell Polychromos

Prismacolor Premier

Prismacolor Verithin

Caran d'Ache Neocolor II

Caran d'Ache Pablo

Caran d'Ache Supracolor II

Derwent Coloursoft

INTRODUCTION

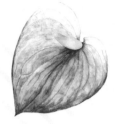

▨ Twenty years ago, I produced my first book for North Light, **Creating Textures in Colored Pencil**. Ten books later, you have in your hands my latest tome, **Creative Colored Pencil**. Although the style of this book may be similar to others I have written, the contents are very different. Before you is a book that deals exclusively with colored pencil as a liquid medium—not only as a water-soluble medium, but with wax-based and oil-based colored pencils that are liquefied with a variety of solvents. The demonstrations and techniques featured in this book are unique—have you ever painted with lighter fluid or vodka?

For more than thirty years, I have been on a mission to educate both artists and non-artists alike about the versatility of colored pencil and its place as a serious and unique visual arts medium.

I hope you enjoy the book as much as I did creating it!

Gary Greene
Woodinville, Washington
June 2015

EXPOSED

Colored pencil and water-soluble colored pencil on watercolor paper
28" × 18" (71cm × 46cm)

Prep Work

In this section, I will discuss the materials and tools used in this book. Colored pencils, surfaces and solvents are explored, along with the tools of the trade such as erasers, brushes, applicators, sharpeners and more.

Colored Pencils

Colored pencils consist of four parts: (1) a core, which most people incorrectly call the lead (there is no lead in colored pencils); (2) an extruded cylinder of pigment mixed with a binder, encased by (3) a cedar casing that is either round or hex-shaped (some colored pencils, such as Art Stix and Cretacolor pencils, do not have a casing); and, finally, most colored pencils have (4) a cap at one end, the exception being Prismacolor pencils.

Colored pencils come in three types: wax-based, oil-based and water-soluble. Wax-based colored pencils consist of pigment bound together with wax, while oil-based colored pencils differ in composition because their pigment is bound together with vegetable oil.

Wax- and oil-based colored pencils work exactly the same way with solvents that make them "liquid." The difference between the two is in how they look and feel when they are applied.

Anatomy of a Colored Pencil

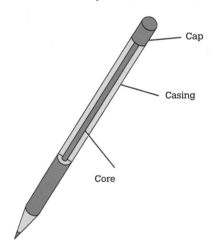

Cap

Casing

Core

Wax-based pencils

Wax-based are the most common colored pencils and have application characteristics that range from dry and hard to soft and creamy, depending on their wax content. Derwent Studio and Derwent Artists pencils are very dry and feel chalky when applied. Prismacolor Premier, Derwent Coloursoft and Caran d'Ache Luminance pencils are soft and apply smoothly. Student-grade pencils are dry, hard, brittle and chalky. They should be avoided because they do not completely liquefy with solvents.

Prismacolor Premier pencils have a color range second to none at 150 colors. They have thick cores and the highest wax content of any colored pencil. Consequently, they are the softest to apply and blend. On the downside, Prismacolor's high wax content causes them to break easily and produce significant wax "bloom"—a thin, powdery, white film of wax that appears on painted areas a day or two after application.

Prismacolor also produces Verithin pencils; they are hard and thin, and especially suited for layouts, fine details and cleaning up rough edges. Another Prismacolor product is Art Stix, a pastel-shaped colored pencil stick without a casing. Verithins have a range of 36 colors, and Art Stix a range of 48; the colors in these brands each match select colors of the Prismacolor line.

Derwent Coloursoft pencils have characteristics similar to Prismacolors—they have thick cores and are soft and creamy. Coloursoft pencils are available in a range of 72 colors.

Caran d'Ache Luminance colored pencils are soft and creamy wax-based pencils, but more important, they consist of ultra-high-quality lightfast pigments, which results in them costing more than three times the price of Prismacolors. Luminance pencils' range is 76 different colors.

Oil-based pencils

Oil-based colored pencils are slightly harder than wax-based, and because there is no wax content, oil-based colored pencils do not bloom. Faber-Castell Polychromos, Caran d'Ache Pablo and Lyra Rembrandt Polycolor are the three oil-based brands, all manufactured in Europe. Pablos are nominally the softest of the three brands, and Polychromos pencils have excellent application characteristics that work well in texture studies. Both Polychromos and Pablo pencils have a range of 120 colors, while the Polycolors are available in 72.

Water-soluble pencils and pastels

Although water-soluble colored pencils, in certain instances, perform like watercolors, they are very different. Nevertheless, they are incorrectly referred to as "watercolor pencils," even by their manufacturers.

There are many brands of water-soluble colored pencils in varying levels of quality. Look for pencils that do not feel dry and chalky when applied and pigment that dissolves completely when water is added. Faber-Castell Albrecht Dürer and Caran d'Ache Supracolor II pencils are excellent, professional-quality brands. Both are available in a range of 120 colors matching their respective oil-based colored pencil lines.

The Caran d'Ache Neocolor II resembles a crayon. It is not a colored pencil, but rather a water-soluble wax pastel, accepted by the Colored Pencil Society of America (CPSA) as a colored pencil. They have a greater wax content than Prismacolor pencils, so they not only dissolve extremely well with water, but easily become viscous when applied to paper on a warmed surface. Neocolor II wax pastels have a range of 120 colors.

Solvents

The use of solvents with wax-based and oil-based colored pencils offers unique creative opportunities even many

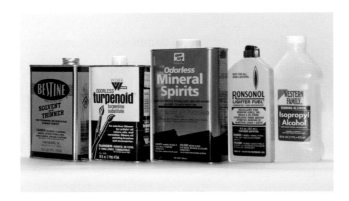

A wide variety of solvents are used in the demonstrations in this book.

experienced artists are not familiar with. Techniques and proper handling are discussed in Part 2 of the book.

Papers

In order to successfully apply wax-based or oil-based colored pencils, the paper surfaces you use should have significant tooth, or texture. The paper should be substantial enough to endure repeated erasure and accept

Tooth (or Texture) of Various Papers

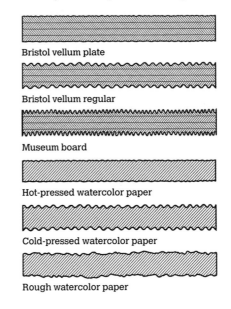

Bristol vellum plate

Bristol vellum regular

Museum board

Hot-pressed watercolor paper

Cold-pressed watercolor paper

Rough watercolor paper

limited amounts of water, should it be necessary to include water-soluble techniques. Highly recommended papers are: Strathmore or Rising 4-ply museum board, and Strathmore Series 500 3-ply or 4-ply bristol vellum (regular surface). Be aware that bristol vellum is also available in a plate surface, but is too smooth for the techniques featured in this book. Both museum board and bristol vellum are 100 percent acid-free. Museum board is available in 32" × 40" (81cm × 102cm) or 40" × 60" (102cm × 152m) sheets that can be cut into smaller sizes, and it comes in a number of colors, such as White, Antique White, Warm White, Polar White (cold white), Black, Cream, Natural (light gray), Fawn (brownish beige), Zinc (French gray), Gray (warm gray), Photo Grey (cold gray) and Medium Grey (medium warm gray).

Your watercolor paper should also have a pronounced tooth and be able to accept solvents used with wax-based or oil-based pencils. Hot-pressed watercolor paper is too smooth and not recommended for the demonstrations in this book. Fabriano Extra White soft-pressed watercolor paper and Arches rough watercolor paper, 300-lb. (640gsm), are suggested for use with both the watercolor and solvent demonstrations. Rough watercolor paper is especially suited to texture studies.

Erasers

Dry wax-based or oil-based colored pencils cannot be completely erased without leaving a ghost behind, regardless of what eraser or method is used. The same applies to colored pencil after it has been liquefied with solvent, although it is erasable to a degree.

Much like trying to erase watercolor, water-soluble colored pencil is much more difficult to erase after it has been wet and dried; however, it erases much like wax-based or oil-based colored pencil before water is

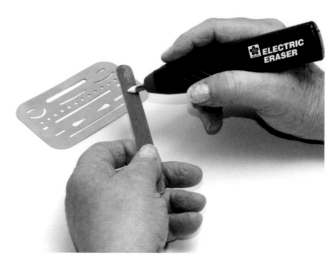

Electric erasers: AC eraser with imbibed (yellow) strip (center); battery-operated, electric eraser with vinyl (white) strip (at right). An abrasive (gray) strip can be used in small areas when working on rough watercolor paper.

Electric eraser strips can be sharpened using an emery board. An erasing shield like the one shown can help you better control your erasing.

added. The best solution (no pun intended) to erasing water-soluble colored pencil after it has dried is to use a wet cotton-tipped applicator or brush. An abrasive eraser can be used on small areas when using rough watercolor paper.

A kneaded eraser is most commonly used for erasing wax-based and oil-based colored pencil by hand. Kneaded erasers are debris-free and are effective when pushed into the paper to lift "crumbs" left by soft, wax-based colored pencils.

A yellow imbibed eraser is imbued with erasing fluid. Imbibed erasers are primarily designed to remove India ink from drafting film, but they also do an excellent job of erasing large areas of colored pencil without damaging the paper surface. Similarly, white vinyl erasers do a satisfactory job of erasing colored pencil, especially when used in an electric eraser.

Gray, abrasive erasers, sometimes called "ink erasers," should only be used on small areas of rough watercolor paper. Excessive use of abrasive erasers will damage the paper, preventing additional layers of colored pencil.

Art Gum, Pink Pearl and other rubber erasers should **never** be used with colored pencil. They smear the color around without actually removing it, and they can also damage paper surfaces.

Electric erasers are available in small, battery-operated models and larger, AC (corded) types. Battery-operated electric erasers are efficient for erasing smaller

areas. They come with short, vinyl strips that are quickly used up. AC erasers use longer strips that offer more eraser choices, including vinyl, imbibed and abrasive strips. AC erasers are bulky, though, and not as handy or portable as their smaller counterparts. They are also considerably more expensive.

If you need to erase a small or tight area, you can make a point on an eraser strip by holding an emery board against it while the eraser is turned on. This method works with battery-operated and AC erasers, though the point wears down much more quickly on the small, battery-operated strips.

An erasing shield is a thin aluminum template with holes and strips cut out of the metal. It helps you erase specific places without erasing surrounding areas.

Sharpeners

A pencil sharpener is the most important tool in your colored pencil toolbox because a well-sharpened point is an absolute necessity. There are four types of pencil sharpeners that I will explore here.

An AC or plug-in electric pencil sharpener is absolutely necessary when working with colored pencils. This sharpener should quickly put a needle-sharp point on your pencil and constantly maintain it. To reduce breakage, an auto-stop feature is suggested along with a large basket for catching shavings to reduce frequent emptying. Another important feature is the depth of the

Erasing Colored Pencil Using Manual Erasers

Kneaded eraser

White vinyl eraser

Imbibed eraser

Erasing Colored Pencil with Solvent

Using kneaded eraser

Using battery-operated with vinyl eraser

Using AC with imbibed eraser

Erasing Colored Pencil Using Electric Erasers

Battery-operated with vinyl eraser

AC with imbibed eraser

AC with abrasive eraser

Erasing Water-Soluble Colored Pencil

While dry, with battery-operated vinyl eraser

While wet, with battery-operated vinyl eraser

sharpener's "throat." Pencils can be sharpened to shorter stubs if the sharpener's throat is shallow, getting more usage out of each pencil. While not a priority, some sharpeners have a rotating ring in front with different apertures accommodating various pencil thicknesses.

Battery-operated sharpeners are small and portable. Most have less substantial mechanics that are less capable of putting on sharp points and are quickly worn out.

Manual, handheld sharpeners produce sharp points but are not recommended because they are time-consuming compared to electric sharpeners. When used excessively, manual sharpeners can cause physical problems such as carpal tunnel syndrome. However, only manual sharpeners should be used with Neocolor II wax pastels. Never attempt sharpening Neocolors with an electric sharpener.

Manual sharpeners with a crank produce sharp points, but you will waste a lot of time sharpening and will wear your arm out in the process.

Brushes

Two separate sets of brushes should be used for the demonstrations in this book: a set of natural-hair brushes for working with water-soluble colored pencils, and another set of synthetic "craft" brushes to work with solvents. Unless you are independently wealthy (and what artist is?), using top-quality sable brushes with solvents is like driving a new Lexus or Mercedes in a demolition derby. The chemicals inherent to some solvents used to liquefy wax-based or oil-based colored pencils will deteriorate the brush hair and eventually destroy the adhesive that holds the bristles together. Inexpensive, disposable brushes should always be used with solvents.

Applicators

Cotton-tipped applicators are used with or without solvent to blend colored pencil. The pointed makeup applicators are used the same way but for small, tight areas, while cotton balls are used to cover large areas.

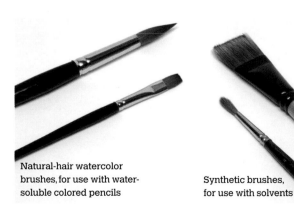
Natural-hair watercolor brushes, for use with water-soluble colored pencils

Synthetic brushes, for use with solvents

Applicators for blending, from left to right: a cotton-tipped applicator, a makeup applicator and a cotton ball.

Watercolor palettes come in various shapes and sizes.

Masking Materials

Masking fluid is used when it is necessary to save areas of the paper from receiving color. It is applied with a disposable brush or toothpicks for small areas. Dried masking should be removed with tweezers or a rubber cement pickup.

Palettes

Use a plastic watercolor palette for liquefying water-soluble colored pencil points, shavings or fragments.

Containers

Having two water containers, one for rinsing and one for cleaning, is not an absolute necessity when working with water-soluble colored pencils as it is for watercolor. However, if both strong and weak colors like red and yellow are being used, two containers might be a good idea. Regardless, water should be changed often to avoid color contamination.

Solvents should be contained in small glass containers with tightly sealed caps to prevent leakage of both liquid and vapors. The cap should be placed over the container, but need not be tightly closed when working with solvents.

Housekeeping Helpers

Your work area should be kept free of debris from pencils, erasers and other sources. A desk brush, also known as a foxtail brush, or a large, soft paintbrush can be used to brush it away. Cans of compressed air can also remove debris without having to touch the artwork.

Colored pencil does not smudge to the degree that pastels, graphite or charcoal does, but a piece of tracing paper should be placed under the heel of the hand, not only to prevent smudging, but to keep oils from your hand from reaching the painting surface.

Paper towels should be kept handy to absorb water from your brush when a dry brush is needed and to clean up spills.

Icarus Drawing Board

The Icarus Drawing Board is heated on one side to soften wax-based colored pencils and Neocolor II wax pastels to an almost viscid consistency when they are applied, creating painterly effects resembling oils, acrylics or gouache. Oil-based colored pencils are not recommended with the Icarus board.

Unpigmented masking fluid is used in this book. It can be removed with a rubber cement pickup (shown) or tweezers.

Tracing paper, compressed air and a desk brush will help keep your workspace tidy and your art protected.

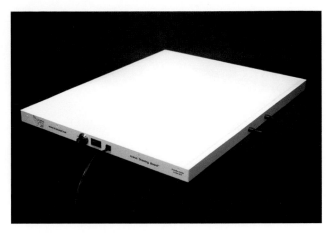

An Icarus Drawing Board can soften selected mediums, making them more workable for creating painterly effects.

Lengtheners

Pencil lengtheners extend the life of pencils, enabling them to be used after they have been ground down to stubs. They come in two versions: thin aluminum cylinders with a locking ring and wooden handles, and substantial all-aluminum holders that tighten down on the pencil.

Lighting

Strong, consistent lighting is important when doing art of any kind. The light source's color temperature should be that of natural light or 5600° K (Kelvin) to ensure that colors are accurately rendered. To avoid shadows, more than one light source should be considered.

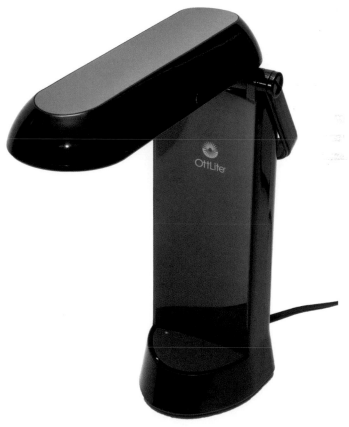

Pencil lengtheners, which come in wood-handled or aluminum models, can make your pencils last longer.

Ott lights provide natural lighting, have a small footprint and are portable.

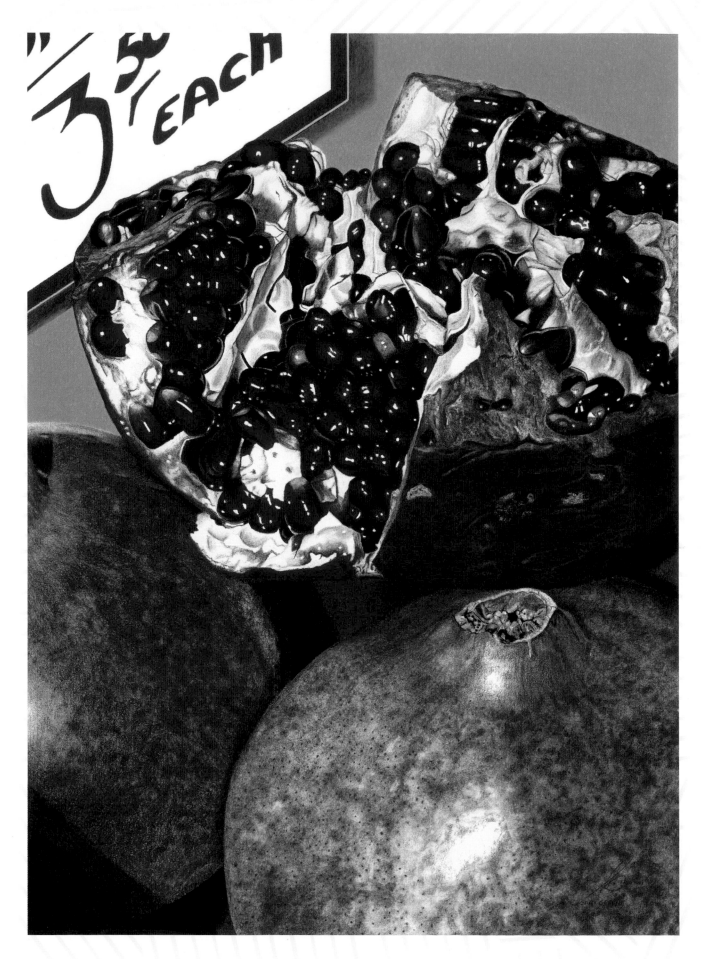

Water-Soluble
Colored Pencil
Techniques

The techniques in this section, such as wet-on-dry and wet-on-wet, may sound familiar to watercolorists and they should because they are basically the same. That being said, there is nothing that can be done with watercolors that can not be done with water-soluble colored pencils, with this proviso: watercolors can not be applied dry, with total control, as a pencil.

All of the technique demonstrations in this and the Part 2 on solvents feature fruits of various simple shapes and colors to help you concentrate on learning the technique rather than the subject. More involved subjects are featured in Part 3.

Inner Beauty

Colored pencil and water-soluble colored pencil on watercolor paper
18" × 14" (46cm × 36cm)

Prep Work

Using reference photos

Unlike art created with wax-based or oil-based colored pencils, water-soluble colored pencil art may not rely as much on reference photos. Water-soluble paintings, like those painted with watercolors, can be painted from life, plein air (on location), or completely ad-libbed, although most of the demonstrations in this book do include reference photos.

Paintings using solvents with wax-based, oil-based or dry colored pencils usually need a reference photo to work from because they tend to be more realistic and detailed, which takes too much time to paint with live subjects.

When you work from photographs, be sure that they are sharp, clear, well exposed and well composed. It is helpful to have some knowledge of photography. It can be as exciting as painting and helps you immensely as an artist. Try it, you'll like it!

If you copy photographs from the Internet, books, magazines or art created in a classroom, you cannot sell or display it publicly or publish it anywhere. Changing a painting enough so the original source is not recognizable is acceptable, but technically, your painting is still not 100 percent original.

Making layouts

A painting's level of realism and detail is directly proportional to the amount of time spent on the layout. From no preliminary drawing at all to a detailed line drawing, the layout determines whether a painting has a loose, impressionistic style, a photo-realistic look or something in between. Art done with dry colored pencils

Shown are some of the reference photos we'll work from later in this book.

Drawn layouts typically contain about this level of detail.

You may feel more comfortable making and working from a traced layout—and this is perfectly acceptable!

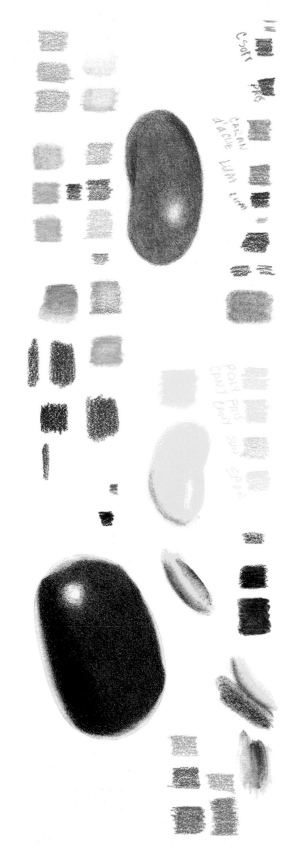

and with solvents tend to be more realistic and detailed, where water-soluble colored pencil art leans more to the loose side.

Layouts for the demonstrations in this book are drawn with heavy lines so they are clearly visible in print. In reality, layout lines should be drawn very lightly so they will disappear when the art is completed. Graphite lines, if used in a preliminary drawing in the layout or if left over from a graphite tracing transfer, should be completely removed before starting, or they will be visible throughout the painting.

The level of detail in a layout should not necessarily show every minutiae. Enough should be drawn to determine accurately where things go and the correct proportions. However, the best way to create a layout for a painting is to simply trace the reference. Despite howls from art snobs, tracing or projecting the basic structure of a painting is perfectly acceptable. It has even been alleged that the Old Masters including da Vinci and Vermeer employed such aids in their paintings.

Distortions are inherent in many photographs, especially those photographed with a wide angle or extreme telephoto focal length. To prevent the painting from looking like it was copied, photographic distortions must be recognized and compensated for by drawing them correctly in the layout.

If you are still reluctant to trace your layout, by all means feel free to draw it from scratch. Just keep in mind that the objective of this book is to teach technique, so it is irrelevant if the layouts are traced or drawn freehand.

Before starting a new painting, practice the elements in it that might be problematic and familiarize yourself with the color palette you want to use. Work on a separate scrap of the same paper you will use for the painting.

How Water-Soluble Colored Pencils Work

Water-soluble colored pencils have been around since the early twentieth century, but only recently have they been recognized as a medium unto their own. As stated before, water-soluble colored pencils are not watercolors, even though they handle similarly and can produce identical results. Unlike watercolors, a single water-soluble colored pencil can be used in all states: as a solid like pan watercolors, as a paste like watercolors from the tube, or as a liquid, all without having to buy separate products. Because of this versatility, anything that can be done with watercolors can be done with water-soluble colored pencil. Moreover, you can do things with water-soluble colored pencils that you can't do with watercolors, such as applying them dry and using them in powdered form.

Water-soluble colored pencils are especially suited for travel due to their portability and easy cleanup.

A traditional water-soluble colored pencil technique involves applying color dry directly from the pencil, then simply brushing on water. Several colors can be applied dry at the same time, or painted in separate layers or glazes with applications of water in between.

Working with One Color

One color,
applied dry Water added

Combining Two Colors

Dry color "A" Dry color "B" Dry "A" + "B" Water added

Layering (Glazing) Two Colors

Dry colors Water added Dry colors Dry colors added Water added

 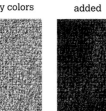

Brush vs. Cotton-Tipped Applicator (for Adding Water)

Dry color Water added with brush Dry rubbed with dry cotton-tipped applicator Water added with brush

Dry color Water added with cotton-tipped applicator Dry rubbed with dry cotton-tipped applicator Water added with cotton-tipped applicator

Traditional Technique

Artists unfamiliar with water-soluble colored pencils almost always employ the traditional technique when using them. If not done properly, this technique can produce unsatisfactory results because too much dry color is applied (especially when applying more than one color) and adding too much water. The results are inconsistent coverage and flat, one-dimensional color that discourage newcomers to the medium.

To produce successful paintings using the traditional technique, areas of color should be completed separately to prevent bleeding. Starting with the lightest area, color is applied with consistent, light strokes, using a well-sharpened point at all times. After the application is complete, color is lightly rubbed with a cotton-tipped applicator or cotton ball to remove excessive color. Water is then applied with a medium-wet brush. Avoid applying too much water; otherwise there will be inconsistent coverage. After drying, it may be necessary to apply additional layers of color.

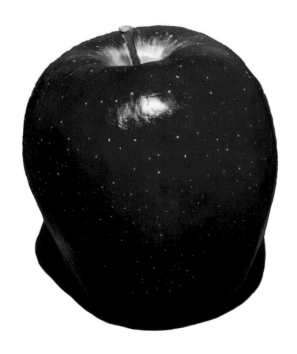

Reference photo

SIMPLE TO START

Simple subjects (fruits or vegetables) with basic shapes and colors are featured for the demonstrations in this section and in Part 2 on solvents to emphasize learning the technique rather than being distracted by the subject. More complex subjects are featured in the demonstrations found in Part 3.

TOOLS & MATERIALS

SURFACE
Fabriano 300-lb. (640gsm) soft-pressed watercolor paper

SUPPLIES
Watercolor brushes: medium flat, small flat, small round
Cotton-tipped applicators
Cotton-tipped makeup applicators

COLOR PALETTE
Faber-Castell Albrecht Dürer:
108 Dark Cadmium Yellow ▪ 176 Van Dyck Brown ▪ 179 Bistre ▪ 219 Deep Scarlet Red ▪ 225 Dark Red ▪ 233 Cold Gray IV

Layout

1

Apply Dry Cast Shadow Color

Apply Cold Gray IV and rub with a dry cotton-tipped applicator.

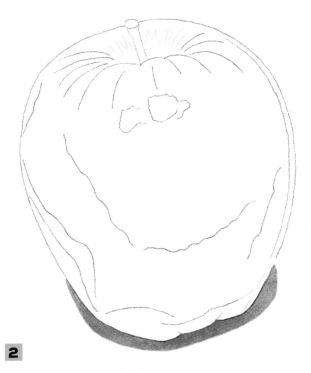

2

Add Water to the Shadow

Apply water with a medium-dry, small flat brush. Before the color dries, carefully wipe the shadow's edge with a moist cotton-tipped makeup applicator.

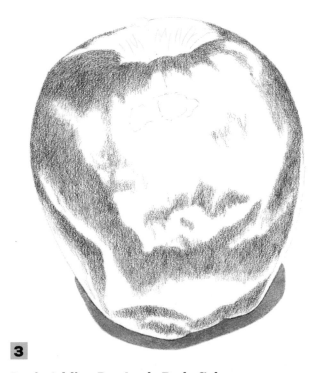

3

Begin Adding Dry Apple Body Color

Apply Dark Red.

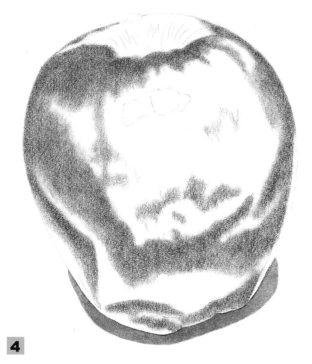

4

Rub Away the Excess

Rub the applied color with a dry cotton-tipped applicator.

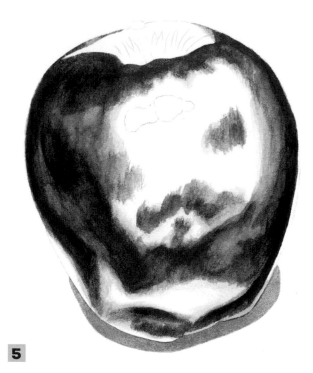

5

Add Water

Apply water with a medium-wet medium flat brush. Leave the paper bare for the highlights.

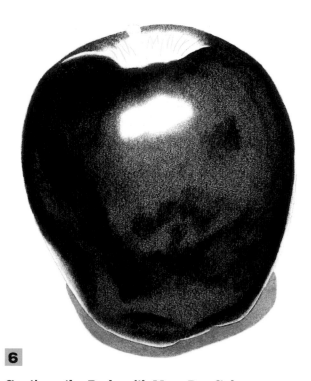

6

Continue the Body with More Dry Color

Apply Deep Scarlet Red.

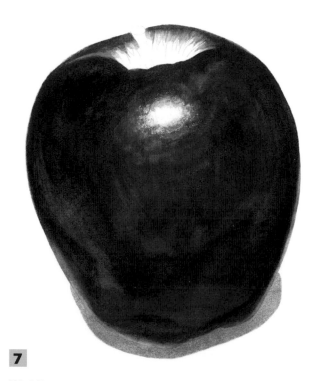

7

Wet It

Apply water with a medium-wet medium flat, making sure to leave an area of bright white highlight.

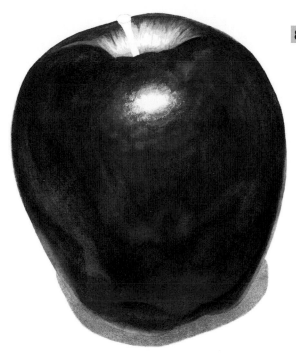

8 Build Detail

Apply Dark Cadmium Yellow, Bistre and Deep Scarlet Red to the core area around the stem. Apply water with a medium-dry small round.

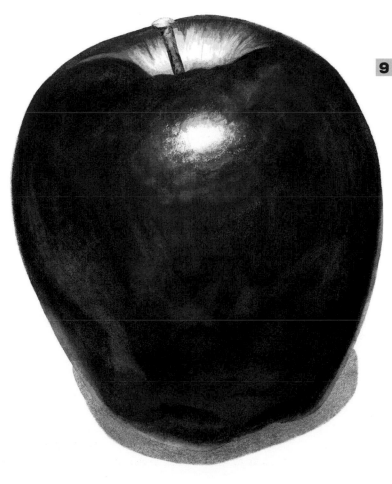

9 Apply Pencil, Then Water to Finish the Stem

Lightly apply Bistre and Dark Red to the stem, and Van Dyck Brown to the top edge of the stem. Apply water with a dry small round. Drag a small amount of color to the top of the stem. Dilute the color as necessary.

Wet-on-Dry Techniques

When a point breaks or a pencil is so short that it can no longer be sharpened, do not discard the remnants—they can be put to many creative uses.

Wet-on-dry techniques involve converting water-soluble colored pencil cores into a liquid medium. When a pencil becomes too short to be sharpened, the remaining core can be removed by carefully squeezing and cracking the wood casing with a pair of pliers until the core is free (be careful not to crush it). Place two ½" (13mm) core pieces into a watercolor palette cup. Additional cores of different colors can be added to the same cup, but it is highly recommended that they be placed in separate palettes, then mixed together.

At this point, there are two options: color can either be taken from the dry cores with a wet brush and applied to the painting, or several drops of water can be added to the cores and allowed to absorb for about an hour, stirring occasionally with the wooden end of a cotton-tipped applicator. When the cores are hydrated, they become soft, like a pinch of watercolor squeezed from the tube. If more water is added, cores become liquid. Alternatively, color can be taken directly from an intact pencil with a wet brush at any time without breaking the casing, but this can weaken the pencil's integrity, due to water continuing to seep into it.

Liquefied color is brushed onto the paper. It can be thinned to the desired consistency with a medium-to-dry brush, depending on what is needed. It may be necessary to apply additional color after the first layer is dry. Different colors can also be applied in thin layers after each layer is dry. The layers should be thin to avoid blocking previously applied color, and the colors should all be about the same intensity (yellows should not be layered on dark blues, for example).

Gently squeezing the pencil with pliers will crack and reveal the core.

Carefully remove the colored core, making sure to keep it intact.

Place two ½" (13mm) core pieces in a palette well.

Add water to the well and let the cores sit for about an hour.

Once hydrated, the cores soften and become workable paint.

Shavings from sharpening Neocolor II wax pastels make an excellent base to liquefy for wet application to wet or dry surfaces. Place the shavings into a watercolor palette cup, then add several drops of water, a few drops at a time. Mix the color with the wooden end of a cotton-tipped applicator until it is thoroughly dissolved. Care should be taken to peel the protective paper wrap around the wax pastels back far enough to prevent sharpening the paper and to keep paper debris from contaminating the shavings.

Shavings that are not immediately used should be stored in small containers like "buddy cups." Manual sharpeners should always be thoroughly cleaned with a cotton-tipped applicator after each use to prevent color contamination. Place the shavings in the watercolor palette cup and add several drops of water, a few drops at a time, then mix with the wooden end of a cotton-tipped applicator until thoroughly dissolved.

Storing cores
Broken points can be stored by color in plastic containers, such as daily medication dispensers, provided each compartment is large enough to hold several points. Longer cores extracted from stubs can be stored in small plastic containers.

Shavings from a Neocolor II wax pastel can be liquefied for use on wet or dry surfaces.

Transferring color
For painting small or delicate details, try rubbing a water-soluble pencil on a scrap of rough watercolor paper, then picking up and applying the color to your painting with a nearly dry brush.

Wet-on-Dry Technique

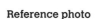 The secret to successfully creating a smooth, continuous texture, as in this banana, is to use light applications of color without stopping and starting the strokes. The simple shape and subtle value changes may appear simple to create but in reality they may require a bit of practice to produce.

Reference photo

Layout

TOOLS & MATERIALS

SURFACE
Fabriano 300-lb. (640gsm) soft-pressed watercolor paper

SUPPLIES
Watercolor brushes: small flat, medium round
Cotton-tipped applicators
Cotton-tipped makeup applicators
Plastic watercolor palette
Two water containers
Eyedropper

COLOR PALETTE
Caran d'Ache Neocolor II:
021 Naples Yellow ▪ 245 Light Olive Green ▪ 250 Canary Yellow ▪ 470 Spring Green
Faber-Castell Albrecht Dürer:
165 Juniper Green ▪ 167 Permanent Green Olive ▪ 175 Dark Sepia ▪ 179 Bistre ▪ 233 Cold Gray IV ▪ 266 Permanent Green ▪ 283 Burnt Sienna

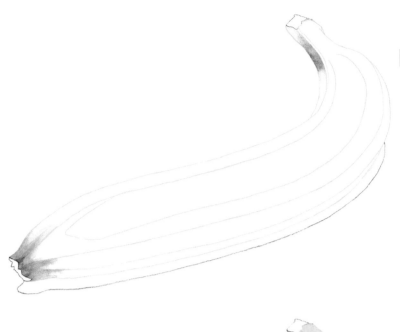

1 Pick Up Color From a Scrap Palette

Heavily apply Juniper Green, Permanent Green Olive and Bistre to a separate scrap of paper. Then apply, as shown, to the art with a nearly dry medium round. Repeat light applications as necessary.

2 Apply Liquefied Color

In a watercolor palette, add shavings of Naples Yellow, Canary Yellow, Light Olive Green, Spring Green and Cold Gray IV to separate wells. Add several drops of water with an eyedropper to each color. Stir each color and allow them to stand for at least an hour. In a separate palette, mix the Spring Green and Light Olive Green. Add an approximately 1/16" (2mm) tip of a Permanent Green core to the Spring Green and Light Olive Green mix. Mix thoroughly and brush on the mixture as shown.

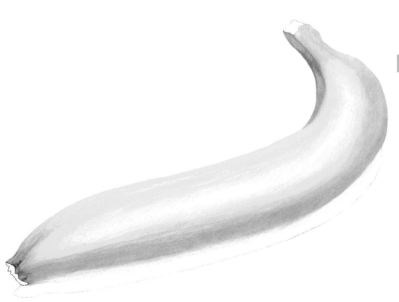

3 Build Up with More Liquefied Color

Apply Canary Yellow to the left quarter portion of the banana with a small flat. Then complete the remaining three-quarters with Naples Yellow and using a medium-small flat.

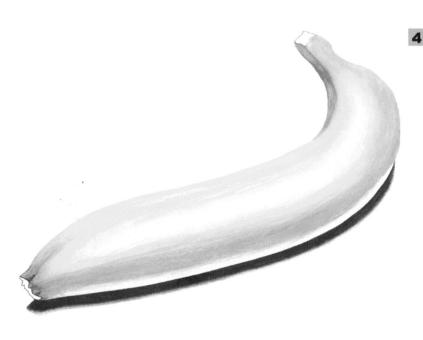

4 Paint the Cast Shadow

Prepare an approximately 6:1 mix of Cold Gray IV to Naples Yellow in a palette well and apply to the cast shadow area.

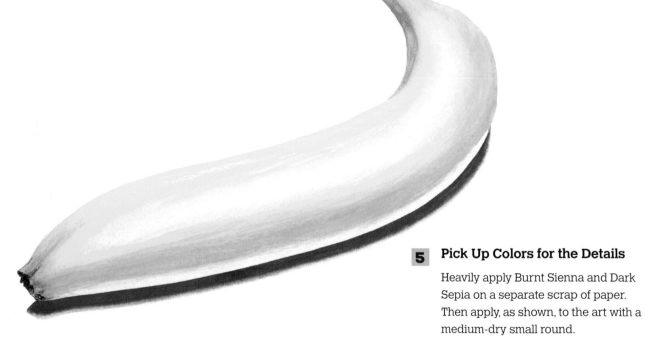

5 Pick Up Colors for the Details

Heavily apply Burnt Sienna and Dark Sepia on a separate scrap of paper. Then apply, as shown, to the art with a medium-dry small round.

How to Work with Masking Fluid

If areas need to be free of color, or objects in a painting are set apart from the background, masking is often required when using wet-on-wet techniques. The easiest, most effective method of masking is with masking fluid, sometimes referred to as liquid frisket. Masking fluid is white or colorless and dries into a latex-like substance.

The masking fluid is applied to dry paper with an inexpensive hobby brush that can be thrown away after use. There are applicators specifically designed for use with masking fluid that can be washed and reused, although the advantages of their use are dubious. Tiny areas can be masked with the wooden end of a cotton-tipped applicator or a toothpick. Care should be taken to apply the fluid as quickly and thickly as possible because it dries rapidly into a rubbery solid. If it is applied too thinly, masking fluid can be a pain to remove. The thicker areas can be removed with your fingers or tweezers. Thinner, more difficult areas can be removed by rolling the dried masking with your fingers or with a rubber cement pickup.

After the masking is removed, it leaves a hard edge. This can be mitigated by rubbing the edge with wet cotton-tipped applicators, scrubbing with a wet bristle brush, feathering with additional color or erasing with an abrasive electric eraser strip.

You must work quickly and thickly when applying masking fluid for best results.

A rubber cement pickup is helpful for removing dried masking fluid, especially in tight places.

Wet-on-Wet Technique

This technique lends itself to loose or abstract styles. The paper is washed with clear water, and the color is applied from the palette with a brush. Wet-on-wet is also good for covering large areas such as skies and backgrounds.

An additional container should be used for holding clear water when using wet-on-wet techniques.

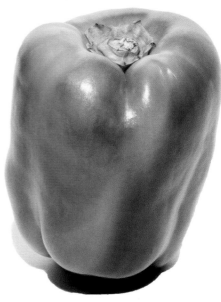

Reference photo

Layout

TOOLS & MATERIALS

SURFACE
Fabriano 300-lb. (640gsm) soft-pressed watercolor paper

SUPPLIES
Watercolor brushes: medium flat, medium to small round, small synthetic round (for applying optional masking)
Cotton-tipped applicator
Winsor & Newton Colourless Art Masking Fluid
Tweezers
Abrasive electric eraser
Plastic watercolor palette
Two water containers
Fine-mist atomizer
Eyedropper

COLOR PALETTE
Faber-Castell Albrecht Dürer:
108 Dark Cadmium Yellow ▪ 107 Cadmium Yellow ▪ 109 Dark Chrome Yellow ▪ 113 Orange Glaze ▪ 167 Permanent Green Olive ▪ 170 May Green ▪ 175 Dark Sepia ▪ 233 Cold Gray IV ▪ 283 Burnt Sienna

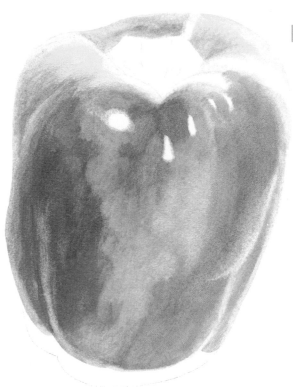

1 Prepare Colors, Apply Masking and Paint the Pepper

In individual watercolor palette wells, add two ⅜" (10mm) lengths each of Dark Cadmium Yellow, Dark Chrome Yellow, Cadmium Yellow, Orange Glaze, Permanent Green Olive and May Green pencil cores. Add several drops of water with an eyedropper to each color. Allow to stand for at least an hour, then stir each with the wooden end of separate cotton-tipped applicators.

If desired, mask the highlights and the top of the crown with masking fluid. Wet the pepper body only with clear water. Separately apply Dark Cadmium Yellow, Dark Chrome Yellow, Cadmium Yellow and Orange Glaze to the wet surface. Thoroughly clean your brush, then apply Permanent Green Olive and May Green. If your initial clear wash begins to dry, add small amounts of water with an atomizer.

While the pepper is still wet, create the secondary highlights by removing color with wet cotton-tipped applicators. When the art is dry, remove the masking with tweezers. Emphasize the secondary highlights with an abrasive electric eraser.

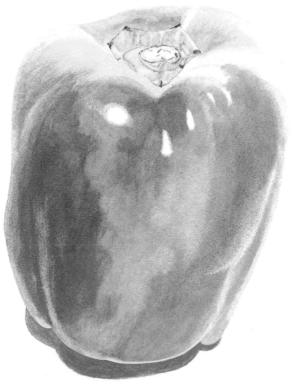

2 Develop the Crown and the Cast Shadow

On a scrap piece of watercolor paper, prepare a palette with separate heavy applications of Permanent Green Olive, Burnt Sienna and Dark Sepia.

Add one ⅜" (10mm) length of Cold Gray IV pencil core to a watercolor palette well, as described in step 1.

Apply clear water to the crown only. When the water is nearly dry, apply a diluted application of Permanent Green Olive from the paper palette with a medium to small round brush.

When the crown is dry, remove the masking with tweezers, then apply a diluted application of Burnt Sienna from the paper palette with a medium to small round. From the same palette, apply the crown details with Dark Sepia.

Lightly wet the shadow with clear water. When almost dry, apply Cold Gray IV. Repeat if necessary.

Dry-on-Wet Technique

This technique involves saturating the paper with clear water and sketching on the wet surface with water-soluble colored pencils, something you cannot do with watercolors. When employing this technique, colors can be blended with a dry or wet brush, and the pencil can be dipped into water before sketching on a wet surface.

The following demonstration produces a mottled texture by using rough watercolor paper and dabbing the moist color with both wet and dry cotton-tipped applicators. To prevent the colors from running together, the color is applied after the paper is allowed to absorb the water, and then it is re-moistened with a fine-mist atomizer if the paper becomes too dry. When rewetting, it is important not to add too much water, so the painted areas do not run. Because rough watercolor paper is more porous, it is more absorbent, which lengthens the drying time, making it easier to work with.

Half of the mangosteen was painted and then the second half was painted; the paper will dry too quickly to paint it all at once.

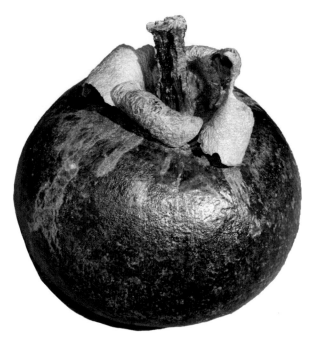

Reference photo

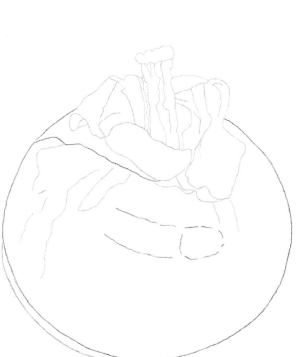

Layout

TOOLS & MATERIALS

SURFACE
Arches 300-lb. (640gsm) rough watercolor paper

SUPPLIES
Watercolor brushes: small flat, medium flat, large flat
Cotton-tipped applicators
Two water containers
Fine-mist atomizer

COLOR PALETTE
Faber-Castell Albrecht Dürer:
107 Cadmium Yellow ▪ 176 Van Dyck Brown ▪ 182 Brown Ochre ▪ 183 Light Yellow Ochre ▪ 186 Terracotta ▪ 193 Burnt Carmine ▪ 223 Deep Red • 225 Dark Red ▪ 249 Mauve ▪ 234 Cool Gray V ▪ 270 Warm Gray I ▪ 271 Warm Gray II ▪ 273 Warm Gray IV
Caran d'Ache Supracolor II:
032 Light Ochre

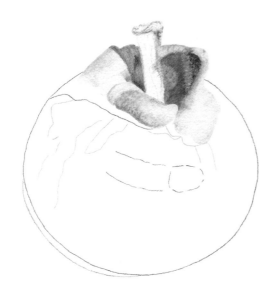

1 Start the Stem, Dry on Wet

Apply clear water to the leaves with a small or medium flat brush. Allow the water to slightly absorb into the paper. With the pencil tips, lightly apply Warm Gray II, Warm Gray I, Light Yellow Ochre, Brown Ochre, Cadmium Yellow, Terracotta, Warm Gray IV and Van Dyck Brown. Go over the applied color with a small or medium flat dry brush.

Apply clear water to the stem with a small, flat watercolor brush. Allow the water to slightly absorb into paper, and then apply Light Ochre, Light Yellow Ochre and Brown Ochre. Go over the applied color with a small or medium flat dry brush.

If the paper becomes too dry, add water with an atomizer.

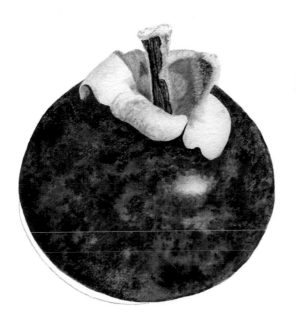

2 Paint the Fruit Body, Half and Half

When the top half of the mangosteen is dry, saturate half of the fruit body with water using a medium flat brush. With random, small circular strokes, apply Van Dyck Brown, Dark Red, Burnt Carmine, Deep Red, Mauve and Cadmium Yellow, leaving the highlight area free of color. Dab with both wet and dry cotton-tipped applicators. Repeat on the other half of the fruit.

Moisten the remaining portion of the stem and apply Van Dyck Brown, Dark Red, Burnt Carmine and Deep Red with linear strokes. Go over the applied color with a small flat dry brush.

3 Complete the Cast Shadow

Moisten the shadow area with clear water. Allow the water to absorb into the paper, but not dry. Then apply Cool Gray V.

Underpainting Technique

Reference photo

The primary purpose of underpainting is to prevent darker, stronger colors from inadvertently mixing with lighter ones. It is also an excellent way to create realistic textures and patterns of color, the latter shown in this demonstration. Underpainting with water-soluble colored pencils specifically produces art with strong color contrasts and coarse textures. Underpainting with solvents combined with dry colored pencils produces more detailed textures, which we will explore in the next section of the book.

The preferred method to underpainting with water-soluble colored pencils is to use the wet-on-dry technique described earlier in this section.

When employing the water-soluble underpainting technique, the wet-on-dry technique is preferred over the traditional technique to prevent the paper surface from being stressed by dry pencils and to avoid the possibility of picking up undissolved pigment that could contaminate colors.

Layouts for water-soluble underpainting should be drawn with dry pencils to prevent colors from being liquefied and contaminating the light-colored underpainting.

Layout

TOOLS & MATERIALS

SURFACE
Fabriano 300-lb. (640gsm) soft-pressed watercolor paper

SUPPLIES
Watercolor brushes: medium flat, small flat, small round, medium round
Cotton-tipped applicator
Plastic watercolor palette
Two water containers
Eyedropper

COLOR PALETTE
Faber-Castell Albrecht Dürer:
103 Ivory ▪ 189 Cinnamon ▪ 233 Cold Gray IV ▪ 270 Warm Gray I ▪ 271 Warm Gray II ▪ 278 Chrome Oxide Green
Caran d'Ache Neocolor II:
031 Orangish Yellow

1 Prepare the Colors and Underpaint

In an individual watercolor palette well, place three ⅜" (10mm) length cores of Ivory and one ¼" (6mm) length core of Warm Gray I. In a second well, add shavings from an Orangish Yellow Neocolor, and in a third well, place three ⅜" (10mm) length cores of Chrome Oxide Green. Fill each well with water from an eyedropper, allow them to sit for at least an hour, then stir each with the wooden end of separate cotton-tipped applicators.

Apply the Ivory and Warm Gray I mixture to the squash with a medium to small flat brush.

2 Paint the Orange Areas

Apply Orangish Yellow with a medium to small flat brush as shown. For even coverage, reapply if necessary.

3 Add Color and Blend

Apply the Chrome Oxide Green from the palette as shown with a medium round watercolor brush for the larger areas and a small round brush for the finer details as necessary.

When the green areas are completely dry, apply small amounts of Orangish Yellow with a completely dry small flat to the areas where the green and orange areas are mixed. Wiping and washing the brush often, continue brushing without adding more Orangish Yellow until the Chrome Oxide Green begins to mix. Do not overwork.

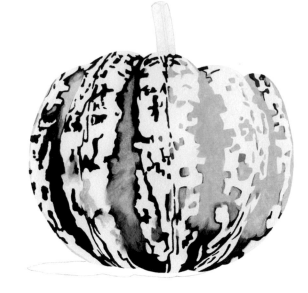

4 Start the Stem

On a separate piece of watercolor paper, prepare a palette with separate heavy applications of Cinnamon and Warm Gray II.

Apply a diluted mixture of Cinnamon and Warm Gray II to the stem with a medium flat brush.

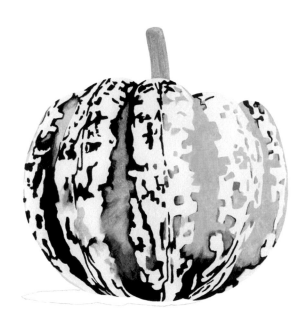

5 Finish the Stem

After the Cinnamon and Warm Gray II mixture thoroughly dries, apply a diluted layer of Chrome Oxide Green with a small, dry round brush.

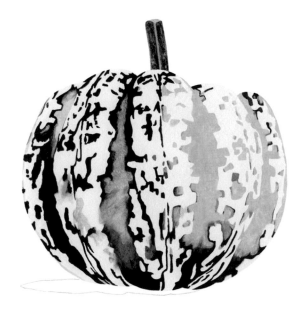

6 **Add the Cast Shadow**

Apply Cold Gray IV and add water
with a medium to small round brush.
Repeat if necessary for even coverage.

Painting with Solvents

◨ Most artists are unaware that wax-based and oil-based (dry) colored pencils can be liquefied with solvents other than water. Using solvents with colored pencils is a relatively new colored pencil technique that has opened many creative possibilities. Although dry colored pencils used with solvents do not achieve the same degree of liquidity as water-soluble colored pencils, techniques can be employed with dry colored pencils with solvents that result in almost unlimited possibilities, including a look similar in appearance to water-based art.

Any number of solvents work with colored pencils. Although most solvents produce similar visual results, some may take on a slightly different appearance, depending on how the solvent is applied, how the paper surface is used and how the technique is employed. The primary differences between solvents lie in their working characteristics, such as how well the solvent liquefies the pigment, how it blends colors and its drying time. Not only are there limitless effects possible with various solvent and pencil combinations, but solvent techniques can be combined with dry colored pencil techniques and water-soluble methods as well.

Character

Colored pencil on
museum board
30" × 20" (76cm × 51cm)

Using Solvents with Wax-Based and Oil-Based Colored Pencils

Solvents frequently used with colored pencil are: Bestine rubber cement thinner, Turpenoid (odorless turpentine), mineral spirits, lighter fluid, and both isopropyl (rubbing) and grain alcohol (vodka, gin, tequila and so on). As long as the solvent is clear, it is worth trying. Experiment using different solvents with colored pencils to determine what best suits what you want to accomplish, but avoid solvents that may be hazardous to your health or the environment.

When applying solvents with a brush, always wipe the brush clean in a dry paper towel before reimmersing it.

Cotton-tipped applicators and cotton balls should always be discarded after each use to prevent color contamination from colored pencil particulates left behind in the solvent. Particulates can be picked up with applicators in subsequent use and contaminate your artwork.

Safely handling solvents

Solvents should be stored in small glass containers with tight-fitting, screw-on caps (such as baby food jars) and larger containers if the solvent is going to be used to cover large areas.

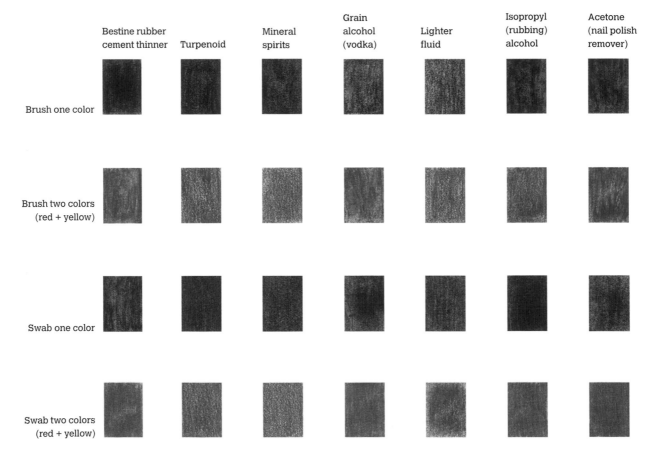

Solvent comparisons

As shown here, it is difficult to visually distinguish differences between solvents applied to swatches of colored pencil. More obvious differences, such as how quickly and thoroughly a solvent liquefies colored pencil pigment, how it works with an applicator or its drying time, determine how a solvent is best suited for a project.

With common sense and proper handling, the solvents featured in this book can be used safely:

- Use solvents in an adequately ventilated area.
- Do not smoke or use solvents near open flames.
- Keep solvents that are in use in glass or acrylic containers with a secure lid.
- Cover solvents that are in use with the container's lid to minimize vapors (it is not necessary to tighten the lid).
- Keep solvents in use to the side to avoid directly inhaling fumes.
- If you are allergic to chemicals, use solvents such as grain alcohol (vodka, gin, tequila).

Applied with a brush

Applied with a cotton-tipped applicator

Applicators make a difference

Solvents can be applied to small areas with brushes, cotton-tipped or makeup applicators; cotton balls and rags can be used to cover large areas. Different effects are produced by using different applicators. For example, applying solvent with a brush produces a "soft" blending, where applications with cotton-tipped applicators blend colors more thoroughly.

	Bestine rubber cement thinner	Turpenoid	Mineral spirits	Grain alcohol (vodka)	Lighter fluid	Isopropyl (rubbing) alcohol	Acetone (nail polish remover)
Liquefy:							
Brush	2	1	3	4	6	5	7
Swab	1	2	3	4	5	6	7
Combine:							
Brush	1	4	2	6	3	5	7
Swab	2	3	1	6	4	5	7
Drying time	1	2	3	5	4	7	6
Odor	4	1	2	3	7	5	6
TOTAL	11	13	14	28	29	33	40
RANK	1	2	3	4	5	6	7

Solvent effectiveness

Here is a subjective comparison of commonly used solvents with colored pencils. The numbers represent how a particular solvent ranks compared to the others in various categories: how thoroughly and quickly a solvent liquefies the colored pencil, using either a brush or cotton-tipped applicator; how a solvent combines more than one color; how long it takes to dry; and how much a solvent's odor may play into its choice. The rankings are added together to determine an overall rank that does not necessarily make one solvent better than another because those with a lower rank may be more suited to do a certain job. Acetone or nail polish remover is mentioned only because it is a commonly found product and does liquefy colored pencil, but not as effectively as the other solvents discussed here, and it is **not** recommended.

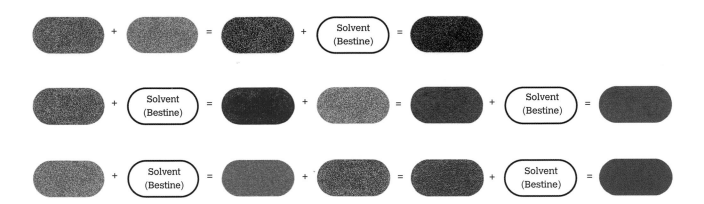

Combining colors when using solvent

Two or more colors can be combined by either applying them dry and blending them together with solvent, or glazing them by adding one color at a time and blending each color with separate applications of solvent. Shown are the results of combining two colors with a solvent: in this case, Bestine rubber cement thinner. Row 1 mixes dry red and blue colored pencil, then adds solvent with a brush. Rows 2 and 3 show one color applied dry, solvent applied with a brush, a second color added dry on top of the first color, and the result of brushing on solvent on top of the two colors. The glazing method is usually more successful with less intense colors. Some solvents, such as grain alcohol, do not take a second color satisfactorily after the first has been applied.

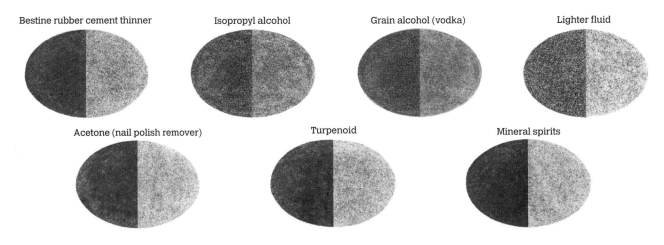

Erasing colored pencil treated with solvents

There is little difference erasing colored pencil after it has been treated with a solvent, and in most cases, colored pencil erases as if it had not been treated at all. Erasing with a small, battery-operated eraser with a white vinyl erasing strip produces the best results. Manual vinyl or imbibed eraser bricks also work with solvents, but it may be difficult to erase small or tight areas, even with an erasing shield. Kneaded erasers, a staple of dry colored pencil art, are not as effective when working with solvents. Quite often, it is difficult to avoid covering areas, such as highlights, when using solvents, but they can be easily erased and become part of the technique being employed.

Bestine Technique

Bestine, a specific brand of rubber cement thinner, is the solvent most widely used in this book. Its working characteristics differ considerably from other rubber cement thinners whose formulations are not the same and mostly produce unsatisfactory results when used with colored pencil. Although Bestine contains chemicals that can be harmful, if used properly, it is relatively safe. Unlike other rubber cement thinners, when used in small quantities, its odor is not pronounced (unless you get too close to an open container) and does not linger in the environment where it is being used the way turpentine does.

There are several reasons why Bestine is an ideal solvent to use with wax-based or oil-based colored pencil:

- It dries almost instantaneously.
- It does not stain or leave a residue on the paper surface.
- It liquefies easily.
- Two or more colors can be applied together, or they can be glazed in separate layers.
- It erases easily.
- It is relatively safe to work with.
- Its relatively mild odor evaporates immediately and does not permeate the work area.

Because it evaporates so quickly, Bestine is most effective for painting small areas. It can be applied with either an inexpensive, synthetic craft brush (**never** use high-quality natural brushes for this purpose) or cotton-tipped applicators. Cotton balls can be used to apply Bestine, but wearing protective rubber gloves is recommended because Bestine leaves a harmless white film on the skin. It is a good idea to wash your hands thoroughly after using Bestine if it comes into contact with the skin.

Reference photo

TOOLS & MATERIALS

SURFACE
Strathmore Series 500 bristol vellum
3-ply, regular surface

SUPPLIES
Bestine rubber cement thinner
Cotton-tipped applicators
Cotton-tipped makeup applicators
Small synthetic flat brush

COLOR PALETTE
Faber-Castell Polychromos:
180 Raw Umber • 183 Light Yellow
Ochre • 184 Dark Naples Ochre • 185
Naples Yellow
Prismacolor Premier:
913 Spring Green ▪ 941 Light Umber ▪
945 Sienna Brown ▪ 947 Dark Umber
▪ 948 Sepia ▪ 1004 Yellow Chartreuse ▪
1012 Jasmine ▪ 1065 Cool Grey 70% ▪
1067 Cool Grey 90%

Layout

1

Lay In Dry Color

Apply Light Yellow Ochre, Dark Naples Ochre, Naples Yellow, Jasmine and Yellow Chartreuse.

2

Apply Bestine

Apply Bestine with a cotton-tipped applicator and a cotton-tipped makeup applicator along the edges.

3

Add Details and Dab

Apply Spring Green, Raw Umber, Light Umber, Sienna Brown, Dark Umber, Sepia, Light Yellow Ochre, Naples Yellow and Jasmine approximately as shown, using light, circular strokes. Using a small flat brush, dab lightly with Bestine.

4

Start the Stem

Apply Raw Umber and Light Yellow Ochre using linear strokes. Lightly dab with Bestine using a small flat brush.

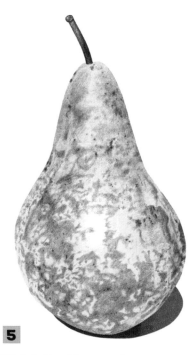

5

Finish the Stem and Cast Shadow

Apply Dark Umber and Sepia using linear strokes. Lightly dab with Bestine using a small flat brush. For the cast shadow, apply Cool Grey 90% and Cool Grey 70%. Then apply Bestine with a cotton-tipped makeup applicator.

Turpenoid Technique

▨ Turpenoid is a brand name for odorless turpentine and is an excellent solvent for colored pencil. It liquefies easily and dries quickly (although not as quickly as Bestine), resulting in consistent blending without gaps and heavy areas. Turpenoid applies well with both cotton-tipped applicators and synthetic brushes.

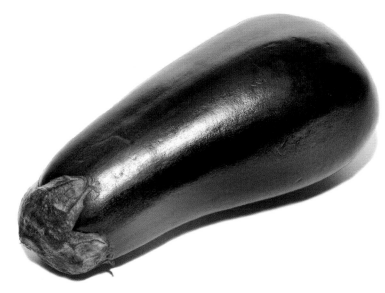

Reference photo

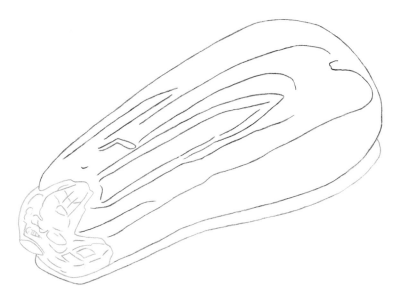

Layout

TOOLS & MATERIALS

SURFACE
Strathmore Series 500 bristol vellum
3-ply, regular surface

SUPPLIES
Turpenoid odorless turpentine
Cotton-tipped applicators
Cotton-tipped makeup applicators
Small synthetic round brush
Small battery-operated eraser with
vinyl strips
Emery board (for sharpening vinyl
strips)

COLOR PALETTE
Prismacolor Premier:
941 Light Umber ▪ 946 Dark Brown
▪ 996 Black Grape ▪ 1005 Limepeel ▪
1063 Cool Grey 50% ▪ 1065 Cool Grey
70% ▪ 1078 Black Cherry ▪ 1091 Green
Ochre

1

Lay In the Cast Shadow

Apply Cool Grey 70% to the center of the shadow. Cover the entire shadow with Cool Grey 50%.

2

Add Turpenoid

Apply Turpenoid with the pointed side of a cotton-tipped makeup applicator.

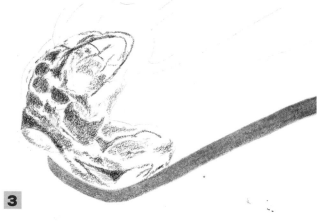

3

Start the Crown

Apply Light Umber and Green Ochre as shown.

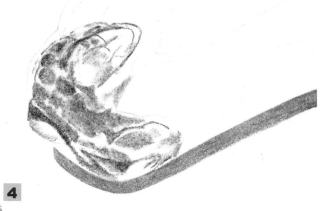

4

More Turpenoid

Apply Turpenoid with the pointed side of a cotton-tipped makeup applicator.

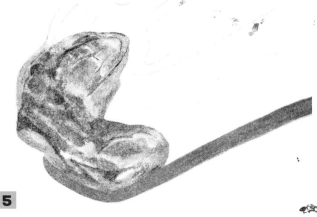

5

Develop the Crown's Color

Apply Limepeel, Dark Brown and Light Umber. Apply Turpenoid with a small, synthetic round brush.

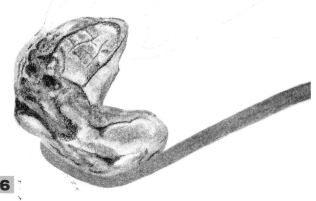

6

Erase for Details

Sharpen a vinyl eraser strip to a point and erase with an electric eraser as shown. Reapply Dark Brown as shown.

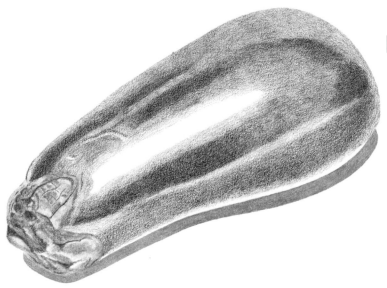

7 Start the Body

Apply Black Grape as shown, leaving the bare paper for a big central highlight and along the bottom edge.

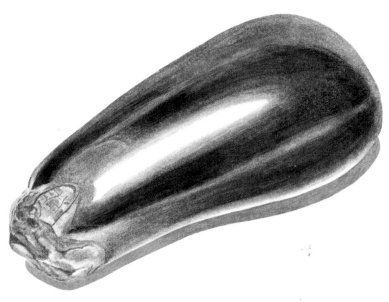

8 Add Turpenoid Again

Apply Turpenoid with a cotton-tipped applicator and a makeup applicator along the edges, using long strokes

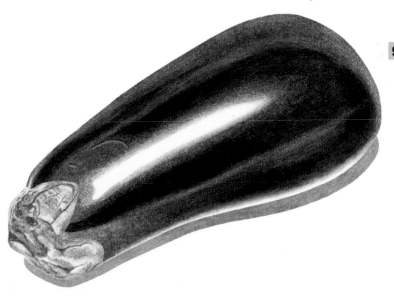

9 Develop the Eggplant's Color

Apply Black Cherry over the Black Grape layer, then apply Turpenoid with a cotton-tipped applicator and a makeup applicator along the edges using long strokes.

Mineral Spirits Technique

Mineral spirits have the longest drying time of all the solvents discussed in this section. The longer drying time allows successful blending of large areas. Mineral spirits take minutes to dry rather than seconds for more rapidly drying solvents, such as Bestine. The longer drying time also dictates the use of cotton-tipped applicators, balls, pads or rags, instead of brushes, which offer less control. Although the odor from mineral spirits is noticeable, it quickly dissipates.

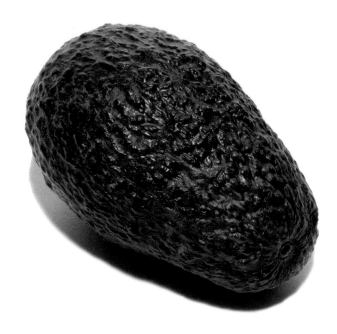

Reference photo

Layout

TOOLS & MATERIALS

SURFACE
Strathmore Series 500 bristol vellum
3-ply, regular surface

SUPPLIES
Mineral spirits
Cotton-tipped applicators
Cotton-tipped makeup applicators

COLOR PALETTE
Prismacolor Premier:
935 Black ▪ 946 Dark Brown ▪ 947 Dark Umber ▪ 1034 Goldenrod ▪ 1065 Cool Grey 70% ▪ 1090 Kelp Green ▪ 1091 Green Ochre

1

Begin the Avocado

Apply Kelp Green and Black using circular strokes, as shown. Randonly apply a small amount of Green Ochre over the entire avocado. Leave the white of the paper for the tiny crown.

2

Carefully Dab Mineral Spirits

Holding a cotton-tipped applicator perpendicular to the art, dab with mineral spirits, leaving some areas free of color. Change applicators frequently. Dab the edges and tight areas with a makeup applicator.

3

Paint the Crown

Paint the circular area at the crown of the avocado with Goldenrod, Dark Brown and Dark Umber. Apply mineral spirits with a makeup applicator.

4

Add the Cast Shadow

Apply Cool Grey 70%. Using a cotton-tipped applicator, apply mineral spirits. Use a makeup applicator along the edge of the shadow and where the shadow meets the body of the avocado.

Grain Alcohol (Vodka) Technique

Grain alcohol works best when used with heavily applied colored pencil because it does not liquefy as easily. It also resists additional applications of colored pencil after the first layer has been liquefied, making it necessary to apply all of the colored pencil dry before adding solvent. Heavy pressure is also required when applying the alcohol, which mandates the use of cotton-tipped applicators rather than a brush.

All types of grain alcohol work similarly and produce comparable results as long as the alcohol is clear. Vodka is a good choice because it is relatively odorless, the most readily available and the least expensive. It should go without saying that unless you wish to consume it, choose the most inexpensive vodka you can find for painting purposes. Depending on how much you are going to use grain alcohol (for artwork), it is recommended that it be purchased in small quantities, preferably in sampler bottles or half-pint bottles at most.

Even though grain alcohol is not toxic like the other solvents, special considerations still should be taken when it is handled. It should be poured into a separate "working" container for painting purposes to avoid the possibility of inadvertently consuming alcohol that has been tainted with colored pencil particulates (although colored pencils are also nontoxic). Applicators should be handled in the same way as with the other solvents, except protective rubber gloves need not be used when applying grain alcohol with cotton balls or rags.

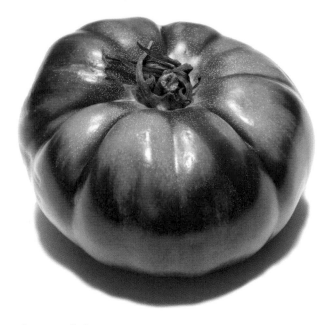

Reference photo

TOOLS & MATERIALS

SURFACE
Strathmore Series 500 bristol vellum
3-ply, regular surface

SUPPLIES
Vodka
Cotton-tipped applicators
Cotton-tipped makeup applicators
Small battery-operated eraser with vinyl strips

COLOR PALETTE
Prismacolor Premier:
908 Dark Green ▪ 909 Grass Green ▪ 910 True Green ▪ 917 Sunburst Yellow ▪ 918 Orange ▪ 921 Pale Vermilion • 922 Poppy Red ▪ 924 Crimson Red ▪ 1002 Yellowed Orange ▪ 1034 Goldenrod ▪ 1063 Cool Grey 50% ▪ 1065 Cool Grey 70% ▪ 1067 Cool Grey 90%

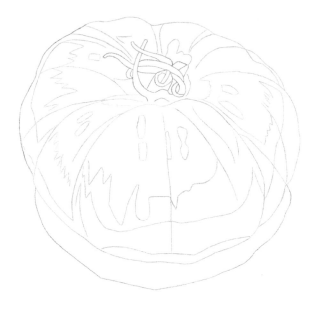

Layout

1

Lay In the Body Color

Apply Sunburst Yellow, Yellowed Orange, Orange, Pale Vermilion, Poppy Red and Crimson Red until most of the paper surface is covered, as shown. Use lighter application on the lower part of the tomato, and leave the paper bare for highlights.

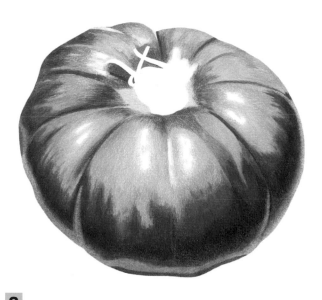

2

Add Vodka and Soften the Edges

Vigorously apply vodka with a cotton-tipped applicator or cotton-tipped makeup applicator. Begin application with the yellow area and replace applicators frequently.

Using an electric eraser with a finely sharpened strip, erase the secondary highlights and lightly reapply Crimson Red and vodka to soften the edges.

3

Finish the Stem and the Cast Shadow

Apply Cool Grey 90%, Dark Green, Grass Green and True Green to the stem area. Apply Goldenrod to the small area adjacent to the stem. Fill in the gaps between the stem tendrils with applicable color from step 1. Lightly dab the stem area with vodka, using a cotton-tipped makeup applicator.

For the cast shadow, apply Cool Grey 90%, Cool Grey 70% and Cool Grey 50%. Apply vodka with a cotton-tipped makeup applicator.

Lighter Fluid Technique

▨ This obviously flammable solvent does not liquefy quickly, is somewhat oily and is slightly yellow in color (although this is not a factor). Lighter fluid does blend easily but requires some pressure with a cotton-tipped applicator to work it into the medium. Using a brush with lighter fluid produces diluted color; for some projects this can be a positive. Though lighter fluid has a fairly strong odor, it does not linger. (In case you are wondering, the subject is a cherimoya.)

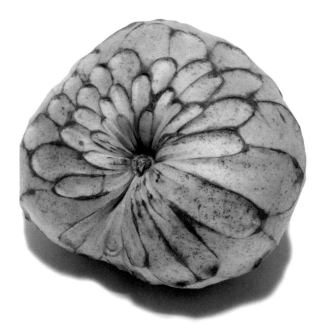

Reference photo

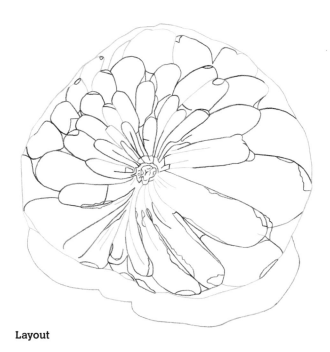

Layout

TOOLS & MATERIALS

SURFACE
Strathmore Series 500 bristol vellum 3-ply, regular surface

SUPPLIES
Ronsonol Lighter Fluid
Cotton-tipped applicators
Small synthetic round brush
Paper towels
Small battery-operated eraser with vinyl strips

COLOR PALETTE
Faber-Castell Polychromos:
170 May Green ▪ 184 Dark Naples Ochre
Prismacolor Premier:
941 Light Umber ▪ 946 Dark Brown ▪ 947 Dark Umber ▪ 948 Sepia ▪ 1063 Cool Grey 50% ▪ 1065 Cool Grey 70% ▪ 1067 Cool Grey 90%

1

Lay In the Base Color and Blend

Apply May Green. Apply less for lighter secondary highlights. Blend the pigment with dry cotton-tipped applicators.

2

Apply Lighter Fluid and Erase, Soften

Apply lighter fluid with cotton-tipped applicators, following the contours of the cherimoya. Erase secondary highlights with a small, electric eraser with a well-sharpened vinyl strip. Reapply lighter fluid to soften the edges, if necessary.

3

Add More Color and Detail

Reapply May Green. Apply Sepia, Dark Umber, Dark Brown, Light Umber and Dark Naples Ochre (center area only).

4

Add More Lighter Fluid and Cast Shadow

Lightly dab on lighter fluid with a well-saturated, small synthetic round brush. Wipe the brush dry on a paper towel after each application.

For the cast shadow, apply Cool Grey 90%, Cool Grey 70% and Cool Grey 50%. Blend with dry cotton-tipped applicators. Apply lighter fluid using cotton-tipped applicators, and cotton-tipped applicators along the edges.

Isopropyl (Rubbing) Alcohol Technique

▨ Found in almost every medicine cabinet, isopropyl alcohol works similarly to grain alcohol, except that it takes somewhat longer to dry and has a strong medicinal odor.

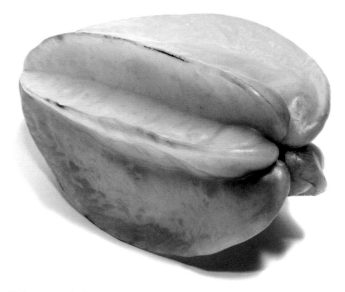

Reference photo

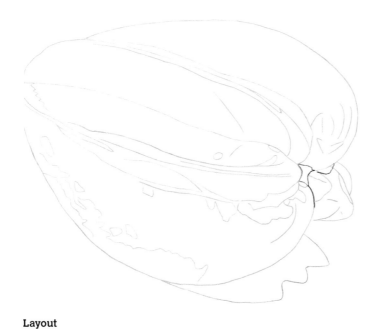

Layout

TOOLS & MATERIALS

SURFACE
Strathmore Series 500 bristol vellum 3-ply, regular surface

SUPPLIES
Isopropyl (rubbing) alcohol
Cotton-tipped applicators
Cotton-tipped makeup applicators
Small battery-operated eraser with vinyl strips

COLOR PALETTE
Faber-Castell Polychromos:
170 May Green ▪ 183 Light Yellow Ochre ▪ 185 Naples Yellow
Prismacolor Premier:
908 Dark Green ▪ 914 Cream ▪ 916 Canary Yellow ▪ 941 Light Umber ▪ 946 Dark Brown ▪ 947 Dark Umber ▪ 989 Chartreuse ▪ 1002 Yellowed Orange ▪ 1003 Spanish Orange ▪ 1004 Yellow Chartreuse ▪ 1005 Limepeel ▪ 1012 Jasmine ▪ 1065 Cool Grey 70% ▪ 1067 Cool Grey 90% ▪ 1090 Kelp Green

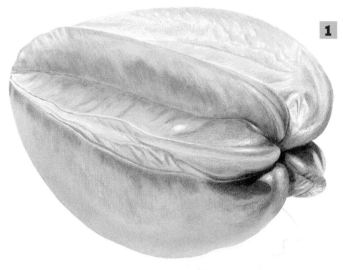

1 Apply the Colors

Apply Dark Umber, Dark Brown, Dark Green, Light Umber and Kelp Green to the shadowed area in front of the star fruit. Gradually add the color until most of the paper is completely covered. Leave the highlights and secondary highlights free of pigment.

 Gradually apply Limepeel, May Green, Chartreuse, Yellow Chartreuse, Yellowed Orange, Light Yellow Ochre, Spanish Orange, Naples Yellow, Canary Yellow and Jasmine to the rest of the starfruit as shown until most of the paper is covered. Leave the highlights and secondary highlights free of color, then lightly add adjacent colors and Cream for the secondary highlights, leaving the primary highlights free of color. If necessary, erase some secondary and primary highlights with a small, electric eraser and a sharpened vinyl strip.

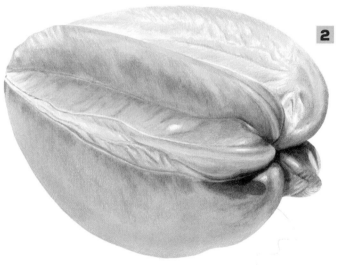

2 Add Rubbing Alcohol

Gently apply alcohol with cotton-tipped applicators, using makeup applicators in tighter areas. Reapply appropriate color if necessary.

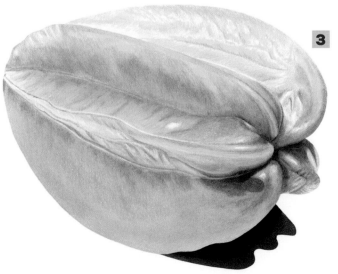

3 Complete the Cast Shadow

Gradually apply Cool Grey 90% and Cool Grey 70% until most of the paper is completely covered.

 Gently apply alcohol with makeup applicators. Reapply color if necessary.

Demonstrations

Now that we have explored some basic techniques in the previous sections, it is time to apply what we have learned to more detailed studies. All of the demonstrations in this section were done on 8½" × 11" (22cm × 28cm) sheets. It is recommended that you work a little larger in order to be more successful. If you work larger, brush size may increase as well.

Some of the demonstrations may differ from the reference art in various ways, but that is what art is all about—changing and improving as opposed to merely copying. Feel free to change the subjects, if you so desire. The objective of the lessons in this book is to learn the techniques so you can apply them to your own projects. Many of the demonstrations in this book may be unfamiliar to you, but obviously you are interested enough to go this far. Remember that everything has a learning curve. If you do not succeed immediately, keep in mind that every endeavor takes practice to master, so be patient with yourself. Have fun!

Backpetals

Colored pencil on
museum board
28" × 19" (71cm × 48cm)

Anthurium

▨ This demonstration features the traditional water-soluble colored pencil technique of applying the pigment with dry pencil, then adding water. Major areas of color are done separately to prevent the colors from bleeding together. It is also a good idea to paint in two or more layers instead of adding all the color at one time.

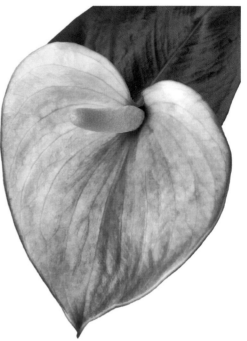

Reference photo

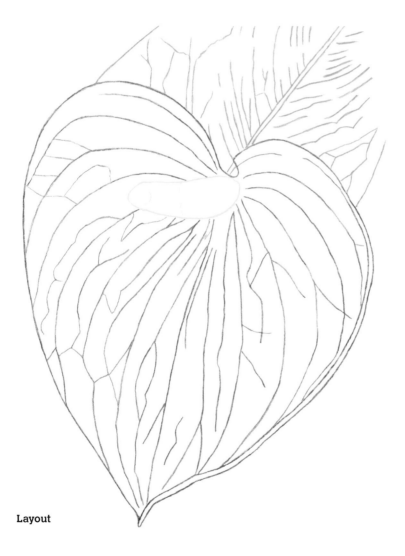

Layout

TOOLS & MATERIALS

SURFACE
Fabriano 300-lb. (640gsm) soft-pressed watercolor paper

BRUSHES
Medium round brush
Medium flat brush

COLOR PALETTE
Faber-Castell Albrecht Dürer:
102 Cream ▪ 103 Ivory ▪ 108 Dark Cadmium Yellow ▪ 109 Dark Chrome Yellow ▪ 123 Fuchsia ▪ 127 Pink Carmine ▪ 128 Light Purple Pink ▪ 129 Pink Madder Lake ▪ 133 Magenta ▪ 165 Juniper Green ▪ 167 Permanent Green Olive ▪ 170 May Green ▪ 174 Chrome Green Opaque ▪ 272 Warm Gray III

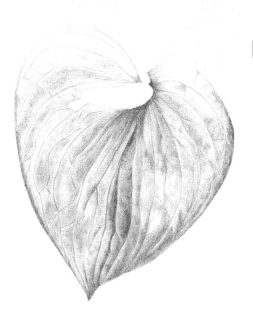

1 Start the Petal

Apply Ivory, Cream and May Green to the upper part of the petal. Apply Magenta to the small area adjacent to the bottom right of the pistil. Apply Pink Carmine, Fuchsia, Pink Madder Lake and Light Purple Pink to the petal, leaving the lightest areas free of color.

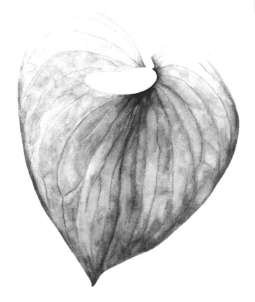

2 Finish the Petal

Apply water with a medium round brush. Reapply color as necessary. Allow to dry thoroughly before proceeding to the next step.

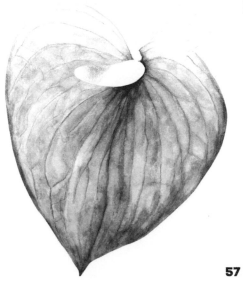

3 Start the Pistil

Apply Warm Gray III as shown.

4 Start the Leaf

Apply water with a medium round brush. Allow to dry fully before proceeding to the next step.

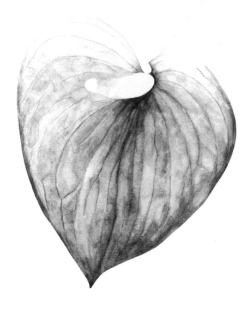

5 Continue the Pistil

Apply Dark Cadmium Yellow and Dark Chrome Yellow to the pistil. Apply water with a medium round brush. Reapply color as necessary. Allow to dry thoroughly before proceeding to the next step.

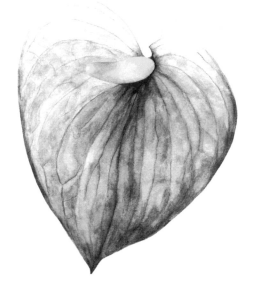

6 Finish the Pistil

Apply May Green to the center vein. Apply Chrome Green Opaque for the darkest values, Juniper Green for the mid-values and Permanent Green Olive for the lighter values. Leave (no pun intended) highlights free of color.

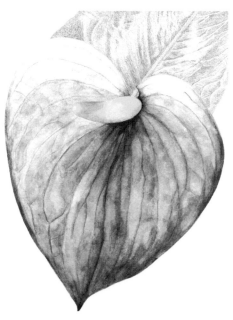

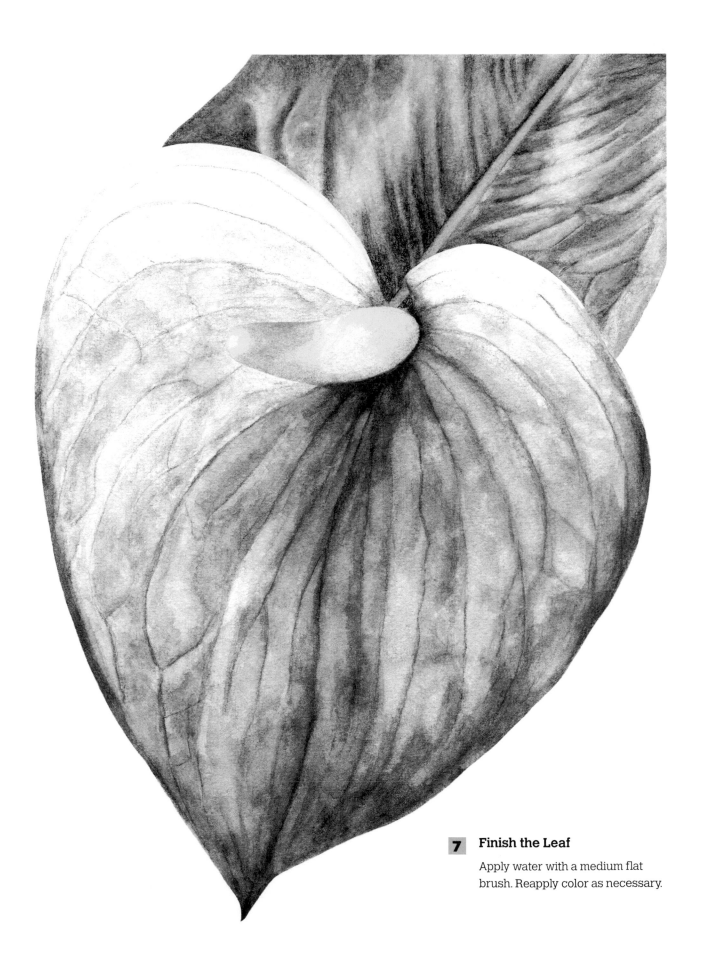

7 **Finish the Leaf**

Apply water with a medium flat brush. Reapply color as necessary.

Burger and Fries

In my neighborhood, there's a high-end burger joint that has the best burgers in the world. This demo is a tribute. It is broken down into six basic areas: the fries, upper half of the bun, lower half of the bun, lettuce, burger and the paper basket liner. To prevent color contamination, the areas with the weakest colors are, for the most part, painted first, and those with the strongest are painted last. Care should be taken to be sure that both the rubber cement thinner and the brush are free of residual color, especially when using strong colors. No two fries are the same, so each is painted separately with different color combinations of the listed colors.

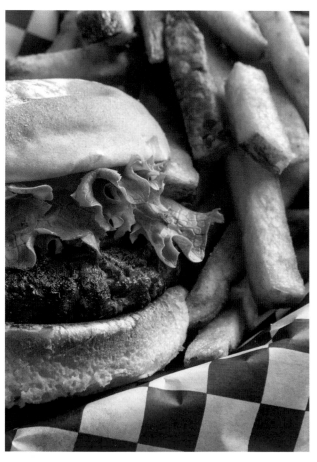

Drawn layout

TOOLS & MATERIALS

SURFACE
Strathmore Series 500 bristol vellum
3-ply, regular surface

SUPPLIES
Synthetic round watercolor brush,
small to medium
Bestine rubber cement thinner
Small glass container
Cotton-tipped applicators
Cotton-tipped makeup applicators
Small battery-operated eraser with
vinyl strips

COLOR PALETTE
Caran d'Ache Pablo:
053 Hazel ▪ 404 Brownish Beige
Derwent Coloursoft:
550 Ginger
Faber-Castell Polychromos:
167 Permanent Green Olive ▪ 180 Raw
Umber ▪ 182 Brown Ochre ▪ 187 Burnt
Ochre ▪ 283 Burnt Sienna
Prismacolor Premier:
908 Dark Green ▪ 911 Olive Green ▪ 913
Spring Green ▪ 914 Cream ▪ 924 Crimson
Red ▪ 925 Crimson Lake ▪ 926 Carmine
Red ▪ 935 Black ▪ 937 Tuscan Red ▪ 940
Sand ▪ 942 Yellow Ochre ▪ 943 Burnt
Ochre ▪ 944 Terra Cotta ▪ 945 Sienna
Brown ▪ 946 Dark Brown ▪ 947 Dark
Umber ▪ 997 Beige ▪ 1012 Jasmine ▪ 1034
Goldenrod ▪ 1060 Cool Grey 20% ▪ 1061
Cool Grey 30% ▪ 1065 Cool Grey 70%
▪ 1067 Cool Grey 90% ▪ 1070 French
Grey 30% ▪ 1072 French Grey 50%
▪ 1082 Chocolate ▪ 1094 Sandbar Brown

Layout

1 **(A) Start a Fry**

Apply Jasmine to the top and Jasmine and Goldenrod to the side and front of the french fry.

1 **(B) Continue the Fry**

Apply rubber cement thinner with a round watercolor brush.

1 **(C) Finish the Fry**

Apply Raw Umber and Burnt Ochre to the front of the french fry. Apply rubber cement thinner.

2 Complete All the Fries and Start the Top Bun

Apply colors approximately per the reference photo to finish the fries.

Apply Sand and Beige to begin the top bun. Smooth with a dry cotton-tipped applicator, then apply rubber cement thinner with a synthetic round brush.

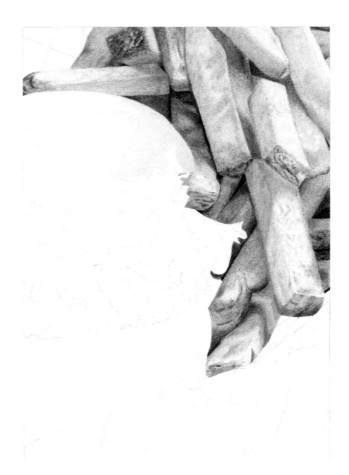

3 Finish the Top Bun

Lightly apply Burnt Ochre (Prismacolor) to the upper part of the bun, leaving bare paper to depict the flour. Smooth with a dry cotton-tipped applicator. Lightly apply Burnt Ochre (Polychromos) and Raw Umber to the lower part of the bun. Smooth with a dry cotton-tipped applicator, then apply rubber cement thinner with a synthetic round brush. Apply Yellow Ochre and Cream to the niche on the right bottom of the bun and apply rubber cement thinner with a round watercolor brush.

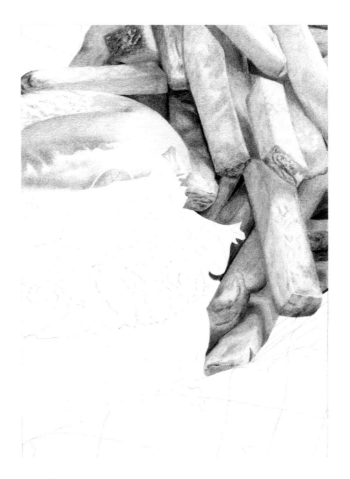

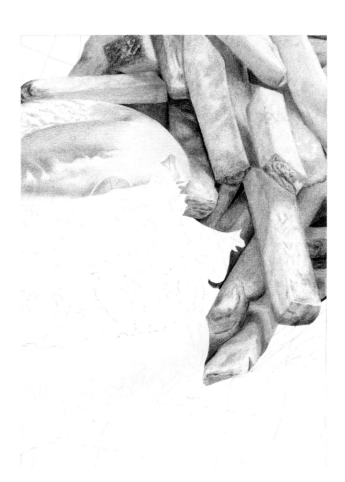

4 Start the Bottom Bun

Apply Jasmine and Cream, then apply rubber cement thinner with a saturated cotton-tipped applicator.

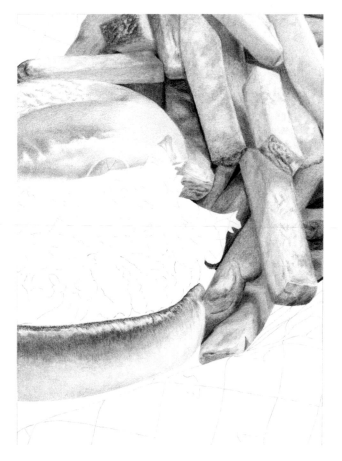

5 Finish the Bottom Bun

Lightly apply Dark Umber, Sienna Brown, Hazel and Ginger to the upper edge of the bun. Soften with a dry cotton-tipped applicator, then apply rubber cement thinner with a small brush. Leave a gap as shown, then apply Sienna Brown, Burnt Ochre, Brown Ochre and Hazel under the gap. Soften with a dry cotton-tipped applicator, then apply rubber cement thinner with a small brush. Lightly apply Raw Umber to the middle, left side and bottom of the bun. Soften with a dry cotton-tipped applicator, then apply rubber cement thinner with a small brush.

If necessary, lighten the right side of the bun with an eraser.

6 Paint the Lettuce

Lightly apply Cool Grey 90%, Dark Green and Olive Green for the darkest values, then soften with a pointed makeup applicator. Apply rubber cement thinner with a small, round brush. Apply Permanent Green Olive for the mid-values, then apply rubber cement thinner with a small round brush. Apply Spring Green for the light values, then apply rubber cement thinner with a small round brush. Leave the paper bare for the lightest values. Reapply color and adjust as necessary.

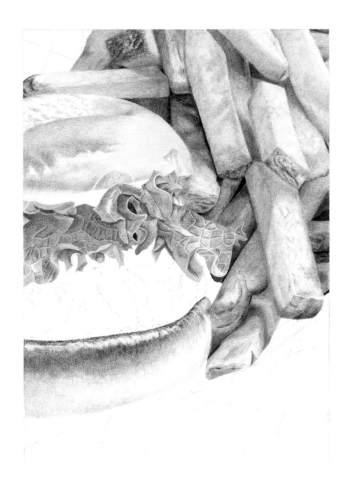

7 Paint the Sauce

Apply French Grey 50% and French Grey 30%, then soften with a makeup applicator. Apply rubber cement thinner with a small brush.

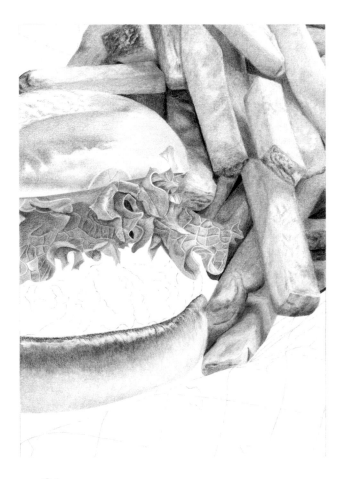

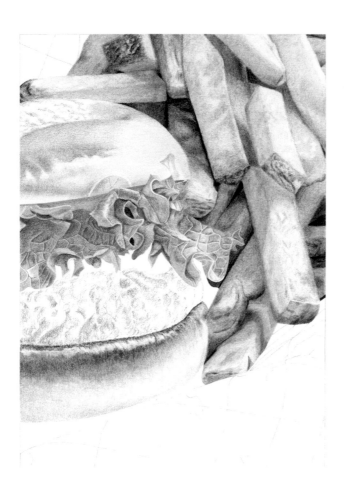

8 Start the Burger

Using tight circular strokes, apply Sandbar Brown and Brownish Beige, then dab ron ubber cement thinner with a cotton-tipped applicator.

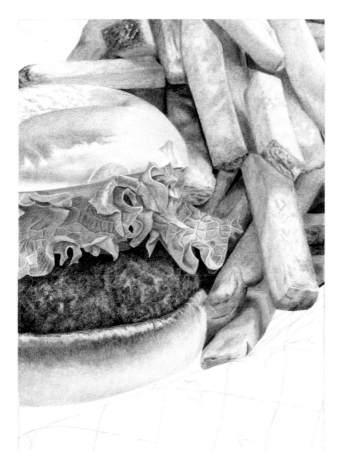

9 Finish the Burger

Using tight circular strokes, randomly apply various amounts of Sandbar Brown, Burnt Ochre, Terra Cotta, Tuscan Red, Chocolate, Dark Brown, Dark Umber and Black. Intermittently dab rubber cement thinner between applications with a small round brush. Repeat as necessary. Erase lighter values with a battery-operated eraser with a sharpened vinyl eraser strip.

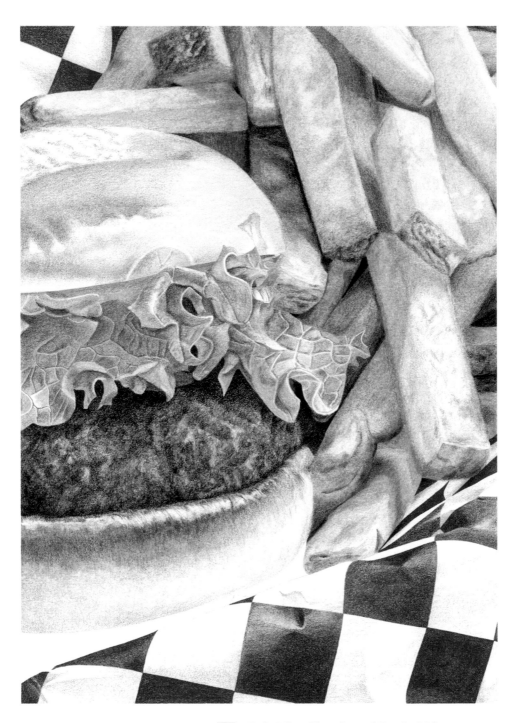

10 Paint the Checkered Basket Liner

Apply Cool Grey 20% and Cool Grey 30% to white squares. Soften with a dry cotton-tipped applicator or makeup applicator. Leave the paper free of color for the lightest values. Apply rubber cement thinner with a small round brush.

Apply Crimson Lake for the red squares' darkest values, Crimson Red and Carmine Red for the mid-values, and Carmine Red for the lightest values. Soften with a dry cotton-tipped applicator or makeup applicator. Apply rubber cement thinner with a small round brush.

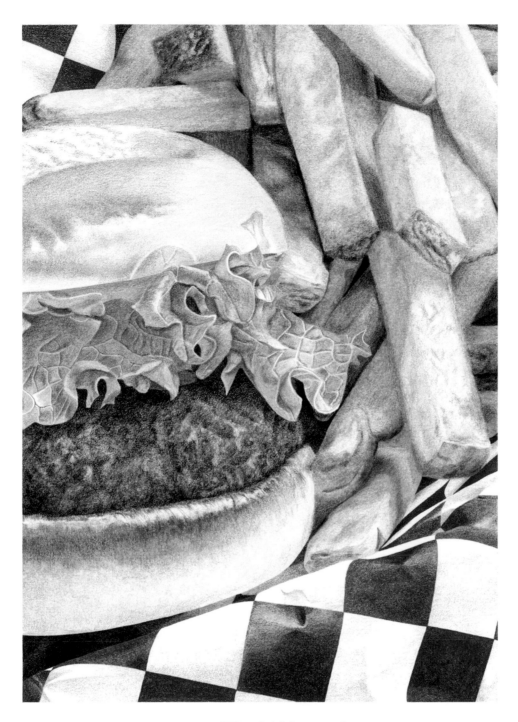

11 Finishing Touches

Apply Cool Grey 70% and Cool Grey 90% to the checkered liner under the lower bun. Soften with a dry cotton-tipped applicator or makeup applicator. Apply rubber cement thinner with a small round brush. Apply Tuscan Red to a small portion of the red squares. Apply rubber cement thinner with a small round brush.

Apply Dark Umber and Sienna Brown to the shaded area under the left side of the lower bun. Apply rubber cement thinner with a small round brush.

Ladles and Wood

This is a texture study of weathered wood, metal, rust and a little bit of brick. To capture the texture of the weathered wood in the upper part of the painting, parallel lines are drawn to create the cracks in the wood, and solvent is applied after each layer of color. Because each color is set with the rubber cement thinner, the colors do not mix together as the textures are built up.

The weathered wood in the lower part of the composition employs underpainting and then layering linear strokes that portray cracks. The ladles are also underpainted, but overlaid with circular strokes.

Although this was intended as a painting done entirely with oil-based colored pencils, it was necessary to use one wax-based Prismacolor because the desired color is not available as an oil-based color.

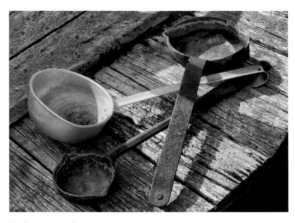

Reference photo

Layout

TOOLS & MATERIALS

SURFACE
Arches 300-lb. (640gsm) rough watercolor paper

SUPPLIES
Bestine rubber cement thinner
Small glass container
Small and medium flat brushes
Cotton-tipped applicators
Cotton balls
Small battery-operated eraser with vinyl strips

COLOR PALETTE
Faber-Castell Polychromos:
111 Cadmium Orange ▪ 115 Dark Cadmium Orange ▪ 132 Light Flesh ▪ 178 Nougat ▪ 186 Terracotta ▪ 187 Burnt Ochre ▪ 188 Sanguine ▪ 189 Cinnamon ▪ 191 Pompeian Red ▪ 192 Indian Red ▪ 225 Dark Red ▪ 230 Cold Gray I ▪ 231 Cold Gray II ▪ 232 Cold Gray III ▪ 233 Cold Gray IV ▪ 272 Warm Gray III ▪ 274 Warm Gray V ▪ 280 Burnt Umber
Prismacolor Premier:
1084 Ginger Root

1 **(A) Start the Upper Wood Texture**

Draw parallel lines with Cinnamon. Apply rubber cement thinner with a small flat brush.

1 **(B) Add Lines**

Draw between the Cinnamon lines with Light Flesh lines. Apply rubber cement thinner with a small flat brush.

1 **(C) Add More Lines**

Randomly draw lines with Burnt Ochre on top of the Cinnamon lines. Randomly layer Ginger Root and apply rubber cement thinner.

1 **(D) Develop the Texture**

Erase random spots with a sharpened eraser strip in a battery-operated eraser as shown. Draw parallel lines with Nougat, Burnt Umber, Cinnamon and Burnt Ochre. Apply rubber cement thinner with a small brush. Repeat as necessary until the desired effect is achieved.

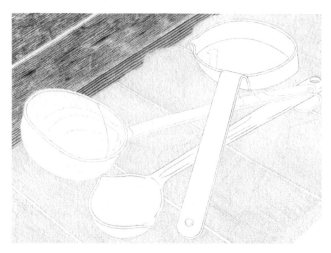

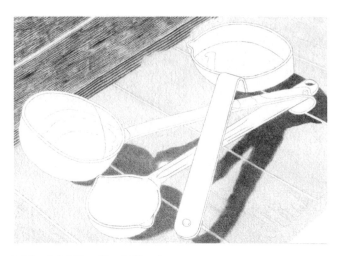

2 **Begin the Lower Weathered Wood**

Using linear strokes parallel with the boards, lightly apply Light Flesh. Wipe in the same direction with a dry cotton-tipped applicator. Lightly layer with Burnt Ochre. Wipe with a dry cotton-tipped applicator. Wipe again with a small, dry cotton ball. Apply rubber cement thinner with a medium flat brush, in the same direction as the wood grain.

3 **Add the Cast Shadows**

Using linear strokes, layer the ladles' cast shadows with Burnt Umber and Nougat. Wipe with dry cotton-tipped applicators. Using a small flat brush, lightly apply rubber cement thinner in the same direction as the grain.

4 **(A) Develop the Wood**

Using linear strokes, lightly layer Light Flesh.

4 **(B) Develop the Wood**

Rub with a dry-cotton tipped applicator, and then lightly layer Burnt Ochre.

4 **(C) Develop the Wood**

Rub with a dry cotton tipped applicator and then with a dry cotton ball.

4 **(D) Develop the Wood**

Using a medium flat brush, apply rubber cement thinner in same direction as the wood grain.

4 **(E) Develop the Wood**

Randomly layer Burnt Ochre with linear strokes as shown. Then, using a medium flat brush, apply rubber cement thinner over the Burnt Ochre areas.

4 **(F) Develop the Wood**

Draw the cracks with Nougat as shown.

4 **(G) Develop the Wood**

Draw the cracks with Brown Ochre as shown.

4 **(H) Develop the Wood**

Draw the cracks with Burnt Umber as shown.

4 **(I) Develop the Wood**

Draw lines with Ginger Root below the cracks, allowing a gap above each crack. Using circular strokes, layer the edge of the board with Nougat and Burnt Umber.

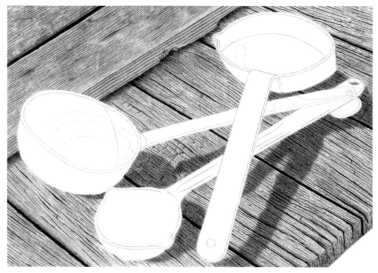

Step 4 completed

5 **Start the Silver Ladle Cup**

Using circular strokes, layer Cold Gray IV, III, II and I. Lightly apply rubber cement thinner with a small flat brush. Repeat if necessary.

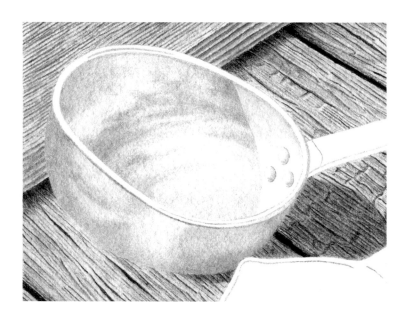

6 **Finish the Silver Ladle Cup**

Lightly layer Cinnamon, Indian Red, Pompeian Red and Burnt Ochre. Lightly rub with a dry cotton-tipped applicator. Lightly apply rubber cement thinner with a small flat brush.

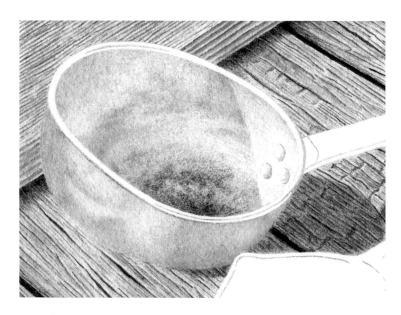

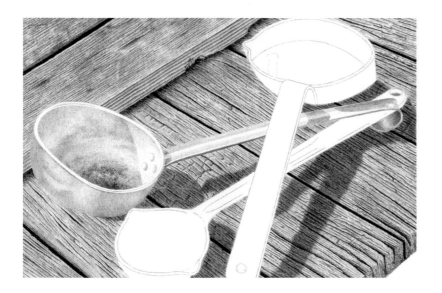

7 **Paint the Silver Ladle Handle**

Layer Cold Gray IV, III and II. Lightly rub with a dry cotton-tipped applicator. Lightly apply rubber cement thinner with a small flat brush.

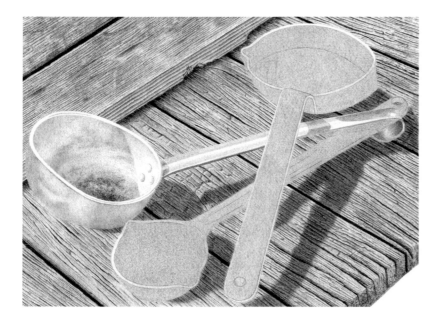

8 **Start the Rusty Ladles**

Apply Terracotta. Rub with a dry cotton-tipped applicator. Lightly apply rubber cement thinner with a small flat brush.

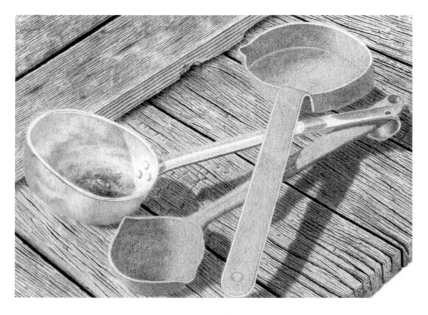

9 **Continue the Rusty Ladles**

Apply Nougat. Lightly apply rubber cement thinner with a small flat brush.

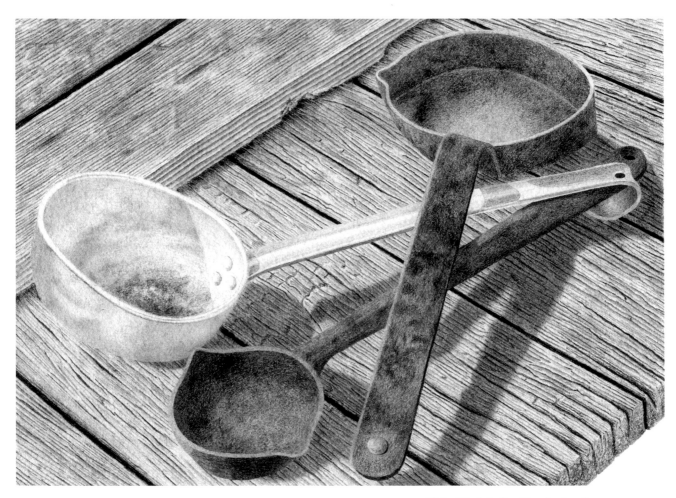

10 **Finish the Rusty Ladles**

Using circular strokes, randomly layer Burnt Ochre, Terracotta, Cinnamon, Cadmium Orange, Dark Cadmium Orange, Dark Red, Nougat and Burnt Umber. Lightly apply rubber cement thinner with a small flat brush.

11 Paint the Brick

Layer the mortar with Warm Gray V and III. Lightly apply rubber cement thinner with a small flat brush. Using small, circular strokes, randomly layer Dark Umber, Dark Red, Indian Red, Sanguine, Burnt Ochre, Terracotta and Cadmium Orange. Lightly apply rubber cement thinner with a small flat brush.

COMBINING DRY COLORED PENCIL AND TRADITIONAL WATER-SOLUBLE COLORED PENCIL TECHNIQUES
Pear Sculpture

▨ The subject of this demonstration is not a shiny, juicy pear—it is a large, decorative sculpture that was found in a greenhouse gift shop. The light blue area and the white highlight near the top center of the pear is actually a reflection of the sky. An oil-based pencil was used to represent the red background texture so it would stay put when overpainted with a water-soluble Neocolor II wax pastel.

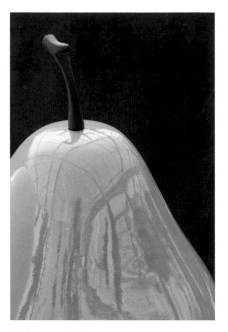

Reference photo

Layout

TOOLS & MATERIALS

SURFACE
Fabriano 300-lb. (640gsm) soft-pressed watercolor paper

SUPPLIES
Prismacolor Colorless Blender Pencil
Watercolor brushes: medium flat, small round

COLOR PALETTE
Prismacolor Premier:
904 Light Cerulean Blue ▪ 912 Apple Green ▪ 913 Spring Green ▪ 920 Light Green ▪ 938 White ▪ 946 Dark Brown ▪ 989 Chartreuse ▪ 1004 Yellow Chartreuse ▪ 1005 Limepeel ▪ 1029 Mahogany Red ▪ 1068 French Grey 10% ▪ 1070 French Grey 30% ▪ 1081 Chestnut
Faber-Castell Polychromos:
192 Indian Red
Caran d'Ache Neocolor II:
070 Scarlet Red

BURNISHING

The burnishing technique involves lightly applying colors on top of one another dark to light, then the same sequence of colors, except the darkest, is re-applied until the paper surface is completely covered, using a colorless blender pencil to cover any remaining paper surface.

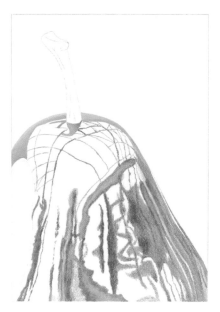

1 Paint the Dark Values

Apply Apple Green, Limepeel, Spring Green, Chartreuse and Yellow Chartreuse. Burnish the dark values with a blender pencil until the paper surface is completely covered.

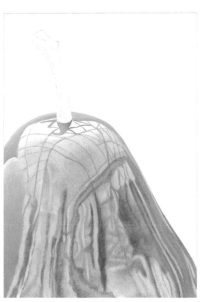

2 Paint the the Light Values and Create the Highlights

Apply Apple Green, Spring Green, Chartreuse, Yellow Chartreuse, Light Green, White and Light Cerulean Blue (for the sky reflection) as shown. Burnish the light values with a blender until the paper surface is completely covered. Leave the paper bare for the highlights.

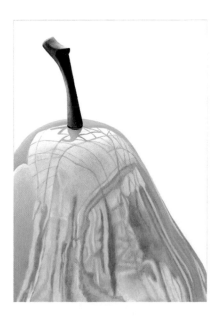

3 Paint the Stem

Apply Mahogany Red, Chestnut and Dark Brown. Burnish the darkest values with French Grey 30%, lighter areas with French Grey 10% and the lightest areas with White. Reapply Mahogany Red, Chestnut and Dark Brown. Burnish with a blender pencil until the paper surface is completely covered.

4 Start the Background

Using the side of the pencil point, randomly apply Indian Red with long vertical strokes.

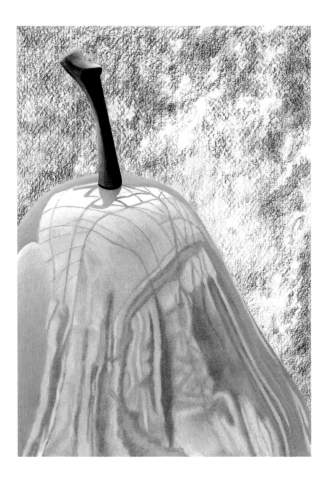

5 Continue the Background

Apply Scarlet Red with long vertical strokes.

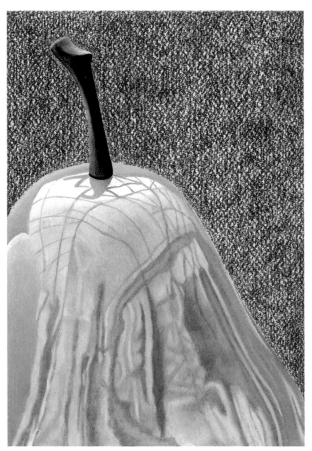

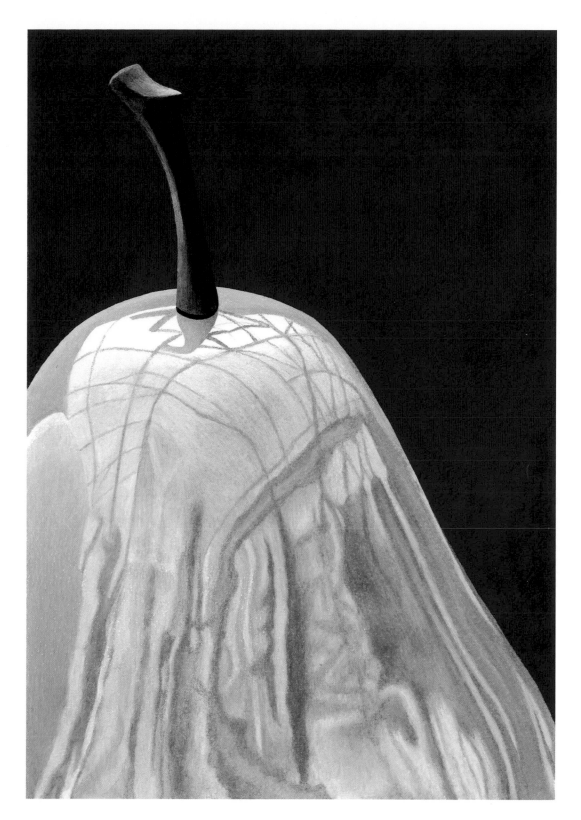

6 **Finish the Background**

Carefully apply water with a medium flat brush. Use a small round brush for the tight areas.

Falls

▨ Because oil-based colored pencils are generally harder than their wax-based counterparts, they are a better choice for fine line strokes such as the water in this demonstration. Keeping the points constantly sharpened and using quick vertical strokes produce a fine water spray. A sharpened eraser strip in a battery-operated eraser was used to create the finer mists of spray.

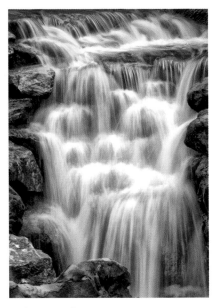

Reference photo

Layout

TOOLS & MATERIALS

SURFACE
Strathmore Series 500 bristol vellum
3-ply, regular surface

SUPPLIES
Bestine rubber cement thinner
Small glass container
Synthetic brushes: small to medium round, small flat
Cotton-tipped applicators
Small battery-operated eraser with vinyl strips

COLOR PALETTE
Faber-Castell Polychromos:
175 Dark Sepia ▪ 180 Raw Umber ▪ 182 Brown Ochre ▪ 186 Terracotta ▪ 231 Cold Gray II ▪ 232 Cold Gray III ▪ 233 Cold Gray IV ▪ 234 Cold Gray V ▪ 280 Burnt Umber ▪ 283 Burnt Sienna
Caran d'Ache Pablo:
404 Brownish Beige

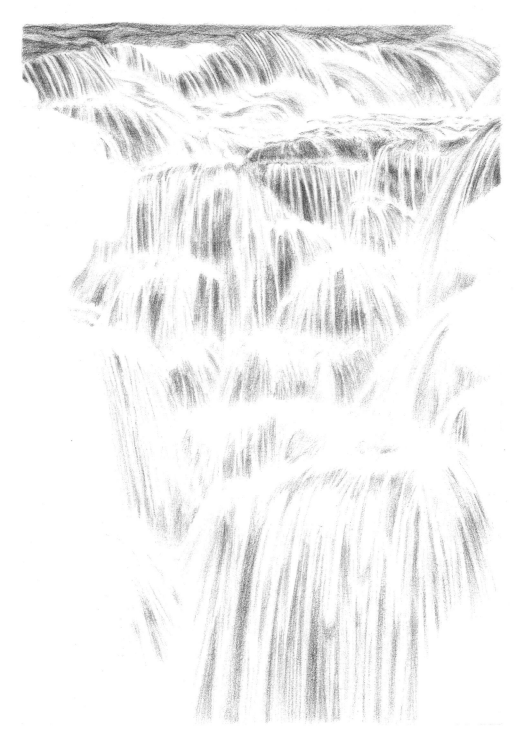

1 **Start the Water**

Painting each cascade separately and using light linear strokes, apply combinations of Dark Sepia, Burnt Umber and Cold Gray IV for the dark values; Raw Umber, Brown Ochre and Cold Gray III for the mid-values; and Brownish Beige and Cold Gray II for the light values. Leave the paper bare for the highlights, and apply Burnt Sienna for the small cascade at the upper center of the falls.

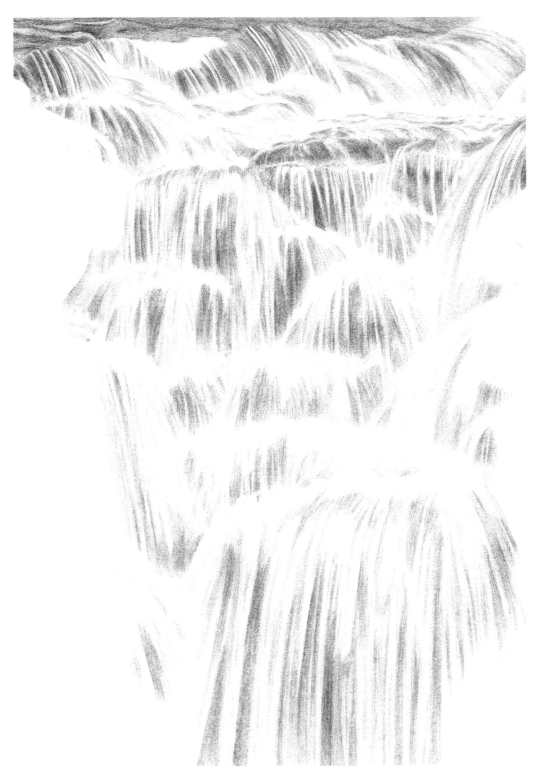

2 **Finish the Water**

Lightly apply rubber cement thinner with a small flat synthetic brush following the flow of the falls. Avoid brushing pigment into the highlight areas. Use a sharpened eraser strip in a small battery-operated eraser to create spray and secondary highlights.

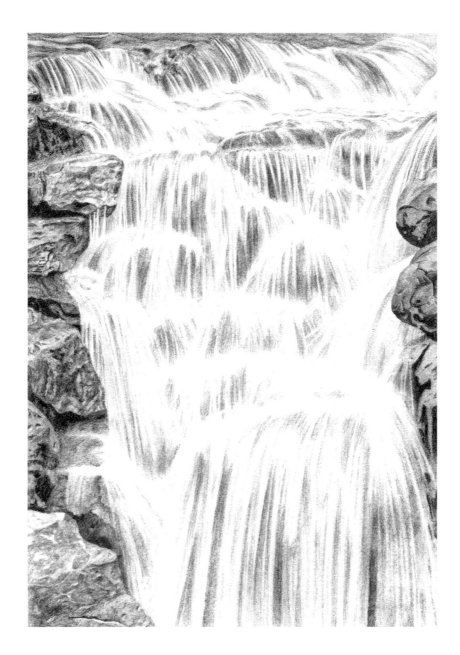

3 Paint the Rocks

Rocks on the left: Apply combinations of Dark Sepia, Burnt Umber, Brownish Beige, Raw Umber, Brown Ochre and Terracotta. Apply rubber cement thinner with a small round synthetic brush, then use a sharpened eraser strip in a small battery-operated eraser to create the overspray and lighter values.

Gray rock on the bottom left: Apply Cold Gray II, III, IV and V. Leave the paper free of color for the quartz (white) marbling. Apply rubber cement thinner with a small round synthetic brush, then use a sharpened battery-operated eraser strip for the lighter values.

Rocks on the right: Apply combinations of Dark Sepia, Burnt Umber, Brownish Beige, Brown Ochre and Terracotta. Apply rubber cement thinner with a small round synthetic brush, then use a sharpened battery-operated eraser strip to create the overspray and lighter values.

Blood Orange

This multifaceted lesson features water-soluble colored pencils, Neocolor II wax pastels and wax-based Prismacolors blended with solvent.

The rind is painted first with dissolved water-soluble colored pencil cores, then the orange peel texture is created by dabbing on liquefied Neocolor shavings with a brush. The pulp's lighter values are brushed on with liquefied water-soluble colored pencil cores. To prevent the lighter pulp from mixing with the red pulp when it is painted over, the lighter pulp is applied with wax-based colored pencil and blended with rubber cement thinner.

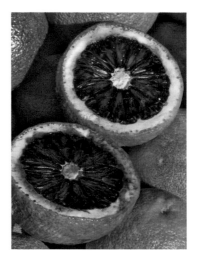

Reference photo

Neocolor shavings

Layout

TOOLS & MATERIALS

SURFACE
Fabriano 300-lb. (640gsm) soft-pressed watercolor paper

SUPPLIES
Bestine rubber cement thinner
Small glass container
Watercolor brushes: small to medium synthetic round, medium round, small round
Cotton-tipped applicator
Plastic watercolor palette
White gesso
Small battery-operated eraser with vinyl strips

COLOR PALETTE
Faber-Castell Albrecht Dürer:
102 Cream ▪ 103 Ivory ▪ 107 Cadmium Yellow ▪ 186 Terracotta ▪ 187 Burnt Ochre ▪ 225 Dark Red ▪ 273 Warm Gray IV ▪ 280 Burnt Umber
Caran d'Ache Neocolor II:
030 Orange ▪ 040 Reddish Orange ▪ 070 Scarlet Red ▪ 085 Bordeaux Red
Prismacolor Premier:
923 Scarlet Lake ▪ 1030 Raspberry

1 Paint the Inner Rind

Place cores of Ivory and Cream (in a 4:1 ratio, approximately) in a palette well and add water. Apply the mixture with a medium round brush.

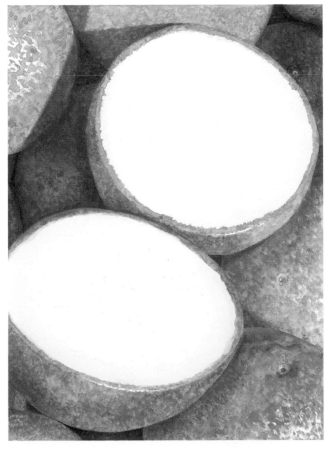

2 Paint the Outer Rind

Place shavings of Orange and Reddish Orange Neocolors into separate palette wells and add 4–5 drops of water to each well. Mix thoroughly with the wooden end of a cotton-tipped applicator until the pigments are completely dissolved. Place the cores of Burnt Ochre, Dark Red and Burnt Umber in separate palette wells and add 4–5 drops of water to each well. Apply the mixture with a medium round brush.

Dab Orange, then Reddish Orange for the peel's lighter values. Leave the paper bare for the highlights. For the darker tones, dab on Terracotta and Burnt Ochre mixtures with Orange and Reddish Orange while they are still wet.

For the darkest values of the cast shadows, dab on mixtures of Burnt Umber, Orange and Reddish Orange.

3 Start the Pulp

Place cores of Ivory and Cadmium Yellow (in an 8:1 ratio, approximately) in a watercolor palette well. Add water and apply a thin mixture with a medium round brush.

4 Continue the Pulp

Apply Raspberry and Scarlet Lake to the pulp area, using less pigment over the previously painted Ivory areas in step 3.

With a small synthetic brush, blend the pigment with rubber cement thinner.

If the Ivory/Cadmium Yellow underpainting is too dominant, thin it by erasing with a small, battery-operated eraser, then reapply Raspberry and Scarlet Lake with an additional application of rubber cement thinner.

5 **Add the Juice and Finishing Touches**

Place shavings of Scarlet Red and Bordeaux Red into separate palette wells and add 4–5 drops of water to each color. Mix thoroughly with the wooden end of a cotton-tipped applicator until the pigment is completely dissolved. In separate palette wells, add more water to increase the dilution of the pigments. Carefully apply the diluted pigment to the rind area with a very dry medium brush. Dilute more for lighter areas. Do not overwork to prevent the Ivory/Cadmium Orange underpainting from mixing.

Apply Warm Gray IV to the centers as shown. Apply water with a small round brush. Apply white gesso with a small round brush to depict the highlights on the pulp.

Lily

▨ This study demonstrates how a black medium works with wax-based colored pencils and solvent, in this case rubber cement thinner. The objective of using solvent is twofold: to soften color and to prevent colors (in this case, the brown and white of the fur) from mixing together by sealing them off.

It is important that linear strokes of various lengths follow the fur patterns. Darker values are created by allowing more paper to show through. Use the Black and Dark Brown pencils sparingly, mainly to make small value adjustments.

If too much color is applied, lift it with a kneaded eraser. Use the battery-operated eraser only when absolutely necessary, and avoid erasing areas that are not to be colored. You want to be sure to maintain sharp edges on the eyes and the nose, so be sure not to use rubber cement on these areas.

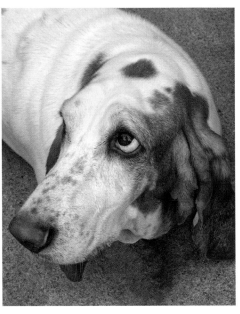

Reference photo ("Lily")

Layout

TOOLS & MATERIALS

SURFACE
Strathmore or Rising 4-ply black museum board

SUPPLIES
Bestine rubber cement thinner
Small glass container
Synthetic round watercolor brush, small to medium
Kneaded eraser
Small battery-operated eraser with vinyl strips

COLOR PALETTE
Faber-Castell Polychromos:
186 Terracotta ▪ 280 Burnt Umber
Prismacolor Premier:
926 Carmine Red ▪ 935 Black ▪ 938 White ▪ 943 Burnt Ochre ▪ 945 Sienna Brown ▪ 946 Dark Brown ▪ 1017 Clay Rose ▪ 1018 Pink Rose ▪ 1031 Henna 1081 Chestnut ▪ 1095 Black Raspberry

1 **Paint the Brown Fur**

Using short, linear strokes that follow the fur's texture, apply Burnt Ochre, Sienna Brown and Terracotta. Apply Dark Brown and Black for value adjustments only. Keep the pencils well sharpened at all times.

Using a small to medium round synthetic brush, lightly dab with rubber cement thinner in the same direction as the strokes. Reapply color as necessary.

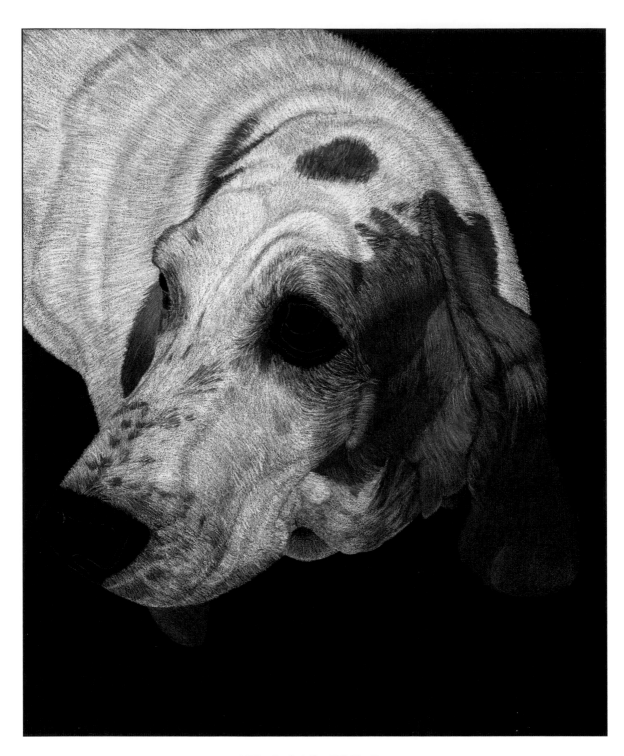

2 Paint the White Fur

Using long, linear strokes on the body and shorter strokes on the head, apply White, adjusting darker values by allowing various degrees of paper to show through. Apply Sienna Brown, Burnt Ochre and Terracotta to connect the brown and white areas of the fur. Apply Black for value adjustments only. Keep the pencils well sharpened at all times.

Using a small to medium round synthetic brush, lightly dab with rubber cement thinner in the same direction as the strokes. Reapply color as necessary.

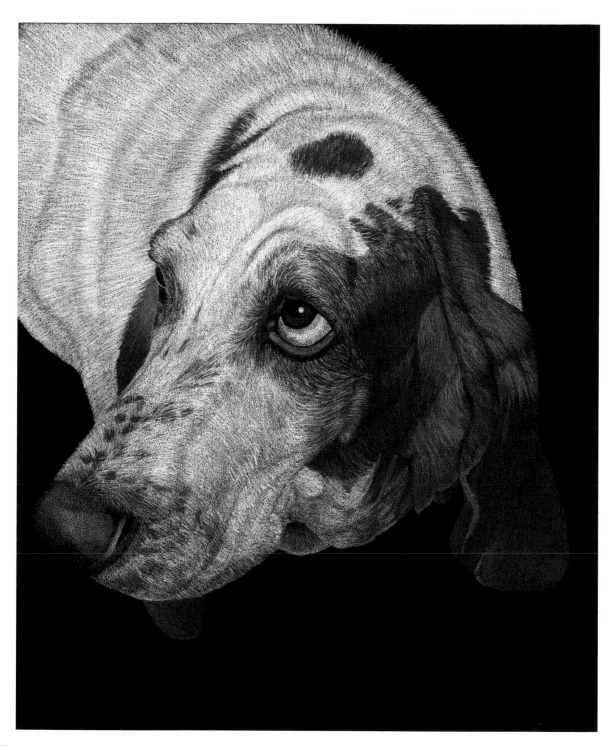

3 **Paint the Nose and Eyes**

For the nose, apply Black Raspberry, Chestnut, Clay Rose, Henna, Burnt Umber and Pink Rose using small, circular strokes. Leave the paper bare and adjust with Black for the nostril's darkest value.

For the eyes, use small, circular strokes to apply Black Raspberry and Burnt Umber for the darker bottom portion of the eyelid; Clay Rose and Black Raspberry for the lighter upper portion of the lower eyelid; White and Carmine Red for the eye's sclera (the white of the eye); Burnt Ochre for the iris. Leave bare (black) paper for the pupil. Add a highlight on the pupil with White.

Flower Pots

This close-up view of decorator flower pots portrays their varied surfaces by employing various water-soluble techniques, including spraying wet on dry pigment.

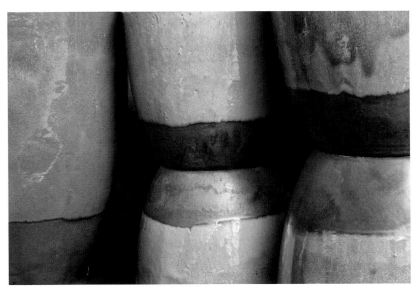

Reference photo

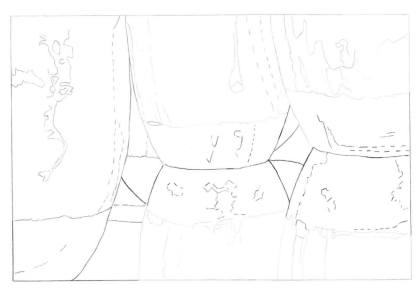

Layout

TOOLS & MATERIALS

SURFACE
Arches 300-lb. (640gsm) rough water-color paper

SUPPLIES
Watercolor brushes: medium round, medium flat
Plastic watercolor palette
Small, fine-mist spray bottle

COLOR PALETTE
Faber-Castell Albrecht Dürer:
109 Dark Chrome Yellow ▪ 111 Cadmium Orange ▪ 115 Dark Cadmium Orange ▪ 145 Light Phthalo Blue ▪ 177 Walnut Brown ▪ 186 Terracotta ▪ 187 Burnt Ochre ▪ 231 Cold Gray II ▪ 232 Cold Gray III ▪ 233 Cold Gray IV ▪ 234 Cold Gray V ▪ 235 Cold Gray VI

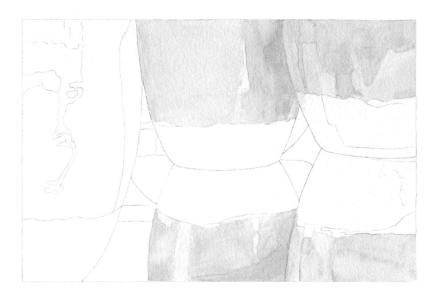

1 **Underpaint the Blue Flower Pots**

Break off the point of a Light Phthalo Blue pencil into a watercolor palette well. Dilute and brush on with a nearly dry medium flat brush. Leave the highlight areas free of color. Allow to dry completely and reapply color if necessary.

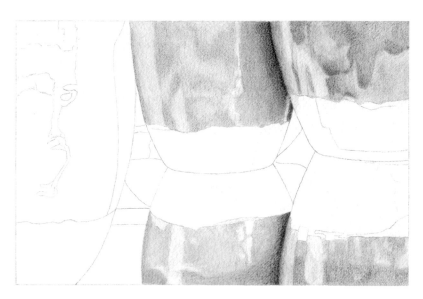

2 **Paint the Blue Flower Pots**

Apply Light Phthalo Blue over the underpainting and Cold Gray III, IV and V to the shadows. Lay the painting flat and lightly spray with water, holding the bottle at least 2 feet (0.6m) directly above the art. Allow to dry and repeat 3–4 times.

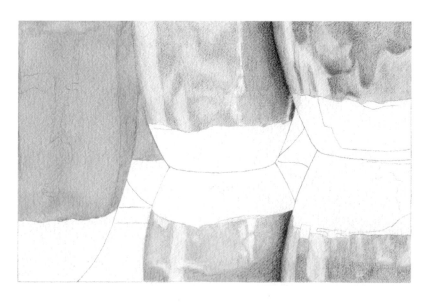

3 **Underpaint the Orange Flower Pots**

Break off the point of a Dark Chrome Yellow pencil into a palette well. Dilute and brush on with a nearly dry, medium flat brush. Allow to dry completely and reapply color if necessary.

4 Paint the Orange Flower Pots

Paint Cadmium Orange over the underpainting andWalnut Brown, Burnt Ochre, Terracotta and Dark Cadmium Orange to the shadow areas. Lay the painting flat and lightly spray with water, holding the bottle at least 2 feet (0.6m) directly above the art. Allow it to dry and repeat 3–4 times.

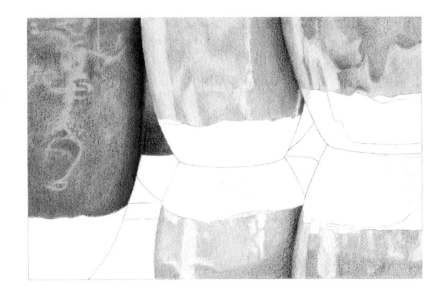

5 Paint the Gray Bases

To paint the orange pots and the two upper blue pots, break the point off a Cold Gray III pencil into a palette well. Dilute and brush on with a nearly dry, medium flat brush. Repeat the process with Cold Gray II for the lower blue pots. Allow the art to dry completely and reapply color if necessary.

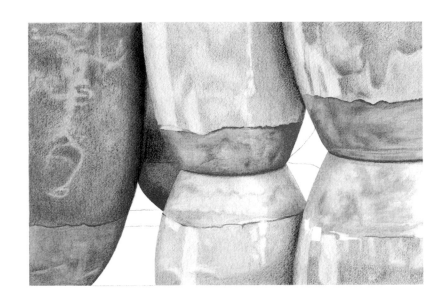

6 Paint the Orange Reflections

Apply a diluted wash of Cadmium Orange for the reflections on the blue pots. Apply Burnt Ochre, Terracotta and Dark Cadmium Orange with a dry, medium flat brush for the shadow on the left side of the blue pot in the upper center. Lay the painting flat and lightly spray with water, holding the bottle at least 2 feet (0.6m) directly above the art.

7 | Paint the Background

Apply Cold Gray IV, V, VI and Light Phthalo Blue (to the right shadow area only). Apply water with a medium round brush. Repeat until completely covered.

SOLVENT TECHNIQUE WITH RUBBER CEMENT THINNER AND COLORLESS BLENDER
Jelly Beans

For those familiar with dry colored pencil techniques, this colorful demonstration shows how hours can be saved by substituting a layer of solvent instead of layer upon layer of dry colored pencil as done with burnishing. By using cotton-tipped applicators instead of a brush for blending colors, the pigment is solidly set deep into the paper instead of just moving it around. Additional color is added on top until the paper is completely covered. It should be noted that although using solvent is faster, it does not produce the same result as burnishing.

The jelly bean colors are changed from the reference photo for additional color and to improve the composition (for example, black and white beans became purple and pink). Feel free to use your own colors.

Since all of the beans are painted the same way, differing only in color, we will show the steps for one bean. Each bean is painted with at least three values.

Reference photo

Layout

TOOLS & MATERIALS

SURFACE
Strathmore Series 500 bristol vellum
3-ply, regular surface

SUPPLIES
Bestine rubber cement thinner
Small glass container
Cotton-tipped applicators
Cotton-tipped makeup applicator
Prismacolor Colorless Blender

COLOR PALETTE
Prismacolor Premier:
905 Aquamarine ▪ 908 Dark Green ▪ 909 Grass Green ▪ 916 Canary Yellow ▪ 918 Orange ▪ 921 Pale Vermilion ▪ 922 Poppy Red ▪ 924 Crimson Red ▪ 925 Crimson Lake ▪ 928 Blush Pink ▪ 929 Pink ▪ 932 Violet ▪ 937 Tuscan Red ▪ 942 Yellow Ochre ▪ 943 Burnt Ochre ▪ 947 Dark Umber ▪ 989 Chartreuse ▪ 992 Light Aqua ▪ 996 Black Grape ▪ 1003 Spanish Orange ▪ 1017 Clay Rose ▪ 1018 Pink Rose ▪ 1033 Mineral Orange ▪ 1072 French Grey 50% ▪ 1088 Muted Turquoise
Prismacolor Verithin:
735 Canary Yellow ▪ 737 Orange ▪ 738 Grass Green ▪ 741.5 Light Cerulean Blue ▪ 742 Violet ▪ 743 Deco Pink ▪ 745 Crimson Red ▪ 756 Dark Umber

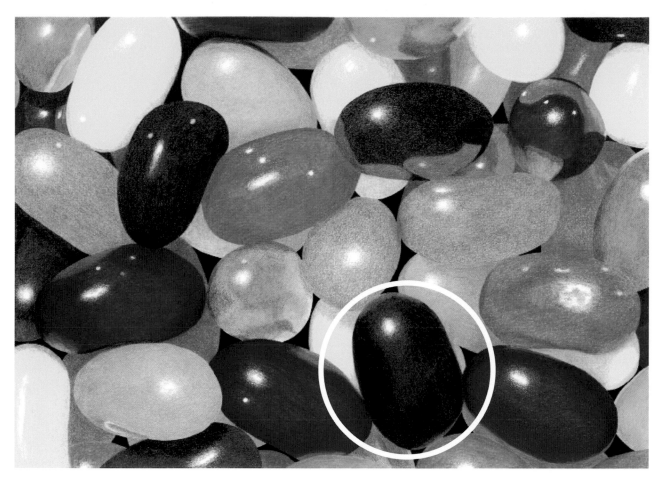

We will break down the jelly bean painting process with this bean in the composition.

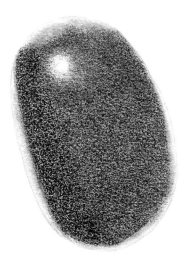

1 **(A) Start the Purple Jelly Bean**

Apply Black Grape to the left side and bottom of the jelly bean.

1 **(B) Cover with Color**

Apply Violet over the entire bean except for the highlight and reflection areas.

1 **(C) Rub and Drag**

Rub with a dry cotton-tipped applicator, dragging color into the reflection areas. Do not drag color into the highlight area.

1 (D) Apply Rubber Cement Thinner

Apply rubber cement thinner with a cotton-tipped applicator and a cotton-tipped makeup applicator in tight areas.

1 (E) Add More Color

Reapply Violet.

1 (F) Develop the Reflections

Apply Crimson Red, Pale Vermilion and Pink Rose to the reflection areas as shown. Burnish with a colorless blender.

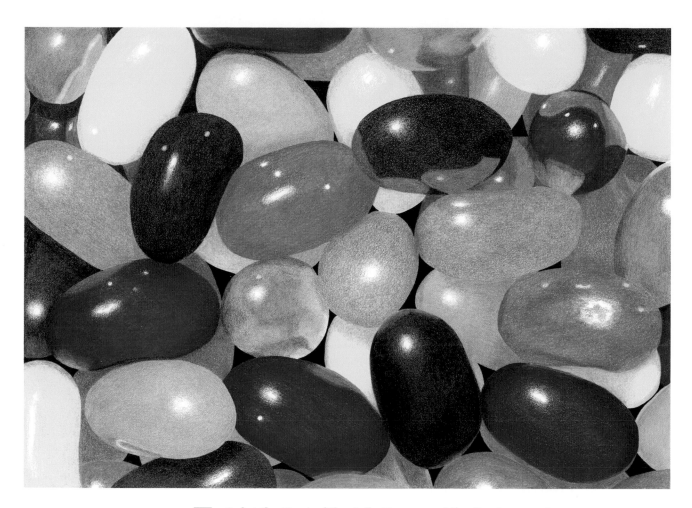

2 **Paint the Rest of the Jelly Beans and the Background**

Follow steps 1A–1F for the remaining jelly beans, substituting colors for the different beans according to the guide below, starting with the darkest hue for each and ending with the lightest, as listed. Then finish by filling in the background.

Aqua beans: Muted Turquoise*, Aquamarine, Light Aqua, Light Cerulean Blue (Verithin)**

Green beans: Dark Green, Grass Green, Chartreuse, Grass Green (Verithin)**

Orange beans: Burnt Ochre*, Mineral Orange*, Pale Vermilion, Orange, Orange (Verithin)**

Pink beans: Clay Rose*, Pink Rose, Blush Pink, Pink, Deco Pink (Verithin)**

Red beans: Tuscan Red*, Crimson Lake, Crimson Red, Poppy Red, Crimson Red (Verithin)**

Violet beans: Black Grape, Violet, Violet (Verithin)**

Yellow beans: French Grey 50%*, Yellow Ochre*, Spanish Orange, Canary Yellow, Canary Yellow (Verithin)**

Background: Dark Umber, Dark Umber (Verithin)**

* For shadows only

** To sharpen edges/layout only

Maple Leaf

▨ Yes, you **can** create loose, wet-on-wet paintings with water-soluble colored pencil. In this demonstration, we paint the leaf with a loose, wet-on-wet technique, then finish it with a dry, burnished background.

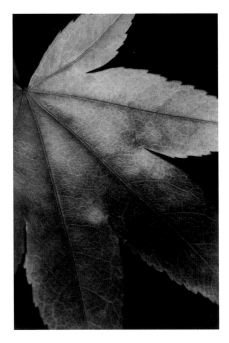

Reference photo

Layout

TOOLS & MATERIALS

SURFACE
Arches 300-lb. (640gsm) rough water-color paper

SUPPLIES
Watercolor brushes: large flat, medium flat, small round
Plastic watercolor palette
Cotton-tipped applicator
Electric eraser with a coarse ink eraser strip
Erasing shield

COLOR PALETTE
Faber-Castell Albrecht Dürer:
108 Dark Cadmium Yellow ▪ 109 Dark Chrome Yellow ▪ 178 Nougat ▪ 183 Light Yellow Ochre ▪ 193 Burnt Carmine ▪ 199 Black ▪ 219 Deep Scarlet Red ▪ 266 Permanent Green
Prismacolor Premier:
935 Black
Prismacolor Verithin:
745 Crimson Red ▪ 745.5 Terra Cotta ▪ 746.5 Tuscan Red ▪ 747 Black
Caran d'Ache Neocolor II:
009 Black

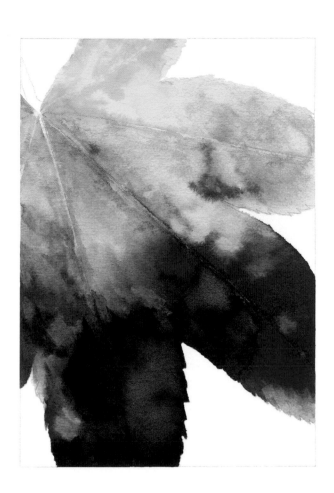

1 Paint On the Color

Place cores of Dark Cadmium Yellow, Dark Chrome Yellow, Burnt Carmine, Deep Scarlet Red and Permanent Green in separate palette wells and add water to each. Apply mixture with a medium watercolor brush.

Using a large flat brush, apply water over the entire paper surface, then add the liquefied Dark Chrome Yellow, Dark Cadmium Yellow, Deep Scarlet Red, Burnt Carmine and Permanent Green with a medium flat brush while the paper surface is still wet. (**Note:** It is suggested that you complete half of the leaf at a time.)

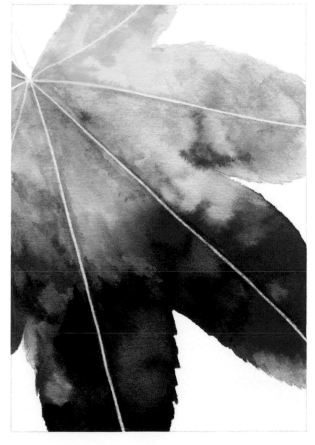

2 Clear the Veins

After the paper is completely dry, erase the vein lines with an electric eraser equipped with a well-sharpened coarse ink eraser.

3 Draw the Veins and Stem

Draw the veins with Terra Cotta, Tuscan Red
or Crimson Red as shown. Apply Light Yellow
Ochre or both Light Yellow Ochre and Permanent
Green to the left edge of the veins. Add water
with a small, nearly dry brush.

 Apply Nougat to the stem. Add water with a
small, nearly dry brush. Apply Dark Chrome Yellow
and apply water with a small, nearly dry brush.

4 Paint the Background

Redraw the outlines of the leaf and edges of the background with a Black Verithin.

Place the shavings of a Black Neocolor into a watercolor palette well and add several drops of water until it's filled. Mix thoroughly with the wooden end of a cotton-tipped applicator until the pigment is completely dissolved.

Apply the liquefied Black to the background areas with a medium flat and a small round brush. To ensure crisp edges, leave a small gap adjacent to the leaf.

Complete the background with a Black Prismacolor, covering the entire surface.

Santa Fe Architecture

Because it blends easily and has an extended drying time, mineral spirits were chosen to underpaint this Southwestern-style building and to create a realistic-looking stucco texture in two layers. The underpainting is done in the usual way with an application of colored pencil and blended with the solvent, using cotton-tipped applicators. After the second layer of colored pencil is applied, a light application of mineral spirits is gently added with a brush. Then the texture is further enhanced by intermittently using a battery-operated eraser, which gives the stucco texture additional dimension.

Solvent is not used on the building's details (belfry, window, door, beams and cast shadows). A straightedge was used to draw the door and window (optional).

Although clouds are not in the reference photo, they were added to the painting to add interest over a solid blue area. Solvent was not used on the sky either.

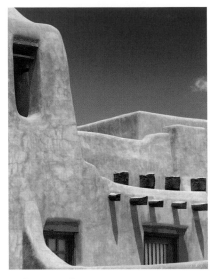

Reference photo

TOOLS & MATERIALS

SURFACE
Strathmore Series 500 bristol vellum
3-ply, regular surface

SUPPLIES
Mineral spirits
Cotton-tipped applicators
Cotton-tipped makeup applicators
Small flat synthetic brush
Small battery-operated eraser with
vinyl strips
Kneaded eraser
Small plastic straightedge (optional)

COLOR PALETTE
Prismacolor Premier:
140 Eggshell ▪ 903 True Blue ▪ 906
Copenhagen Blue ▪ 940 Sand ▪ 941
Light Umber ▪ 942 Yellow Ochre ▪ 947
Dark Umber ▪ 997 Beige ▪ 1051 Warm
Grey 20% ▪ 1052 Warm Grey 30% ▪
1054 Warm Grey 50% ▪ 1082 Chocolate
Faber-Castell Polychromos:
182 Brown Ochre

Layout

1 **Begin Underpainting the Building**

Using circular strokes, apply Beige.

2 **Finish the Underpainting**

Using circular strokes, apply mineral spirits with cotton-tipped applicators.

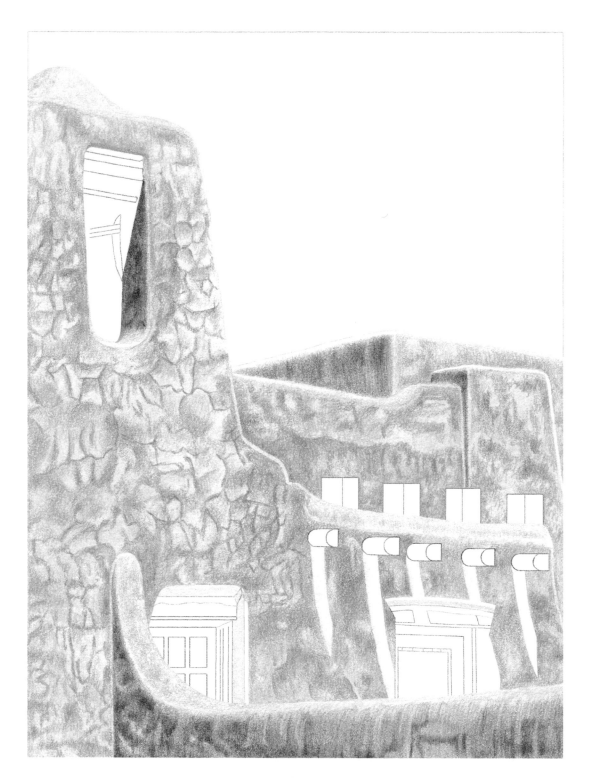

3 **Create the Weathered Stucco Texture**

Using circular strokes, apply Yellow Ochre, Sand, Eggshell, Beige, Brown Ochre and Light Umber.

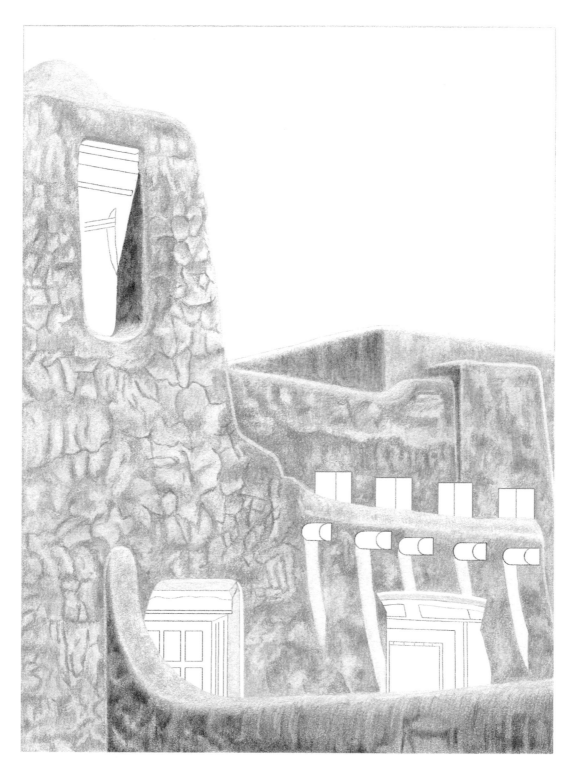

4 Finish the Stucco

Lightly apply small amounts of mineral spirits using a small medium-dry flat synthetic brush. When the solvent is dry, gently erase newly filled-in areas using a small battery-operated eraser with a sharpened vinyl strip. Gently remove any residue with a kneaded eraser.

5 Paint the Details

Belfry: Apply Dark Umber, Chocolate, Light Umber, Brown Ochre, Yellow Ochre and Sand, completely covering the paper surface.

Beams: Apply Dark Umber, Light Umber and Brown Ochre using linear and tight circular strokes.

Cast shadows (cylindrical beams): Apply Light Umber and Brown Ochre.

Door and window glass: Lightly apply Warm Grey 20%. Apply mineral spirits with a nearly dry, small flat brush. Using a light, circular stroke, lightly apply Warm Grey 50% to the door glass (left) and Warm Grey 30% to the window (right).

Horizontal wooden frame: Apply Light Umber, Brown Ochre and Yellow Ochre. Draw the wood grain with Dark Umber.

Door and window frames: Apply Dark Umber and Chocolate with a (optional) straightedge. Draw cast shadows on the glass with Warm Grey 50%.

Door and window offsets and cast shadows: Apply Light Umber, Brown Ochre and Yellow Ochre.

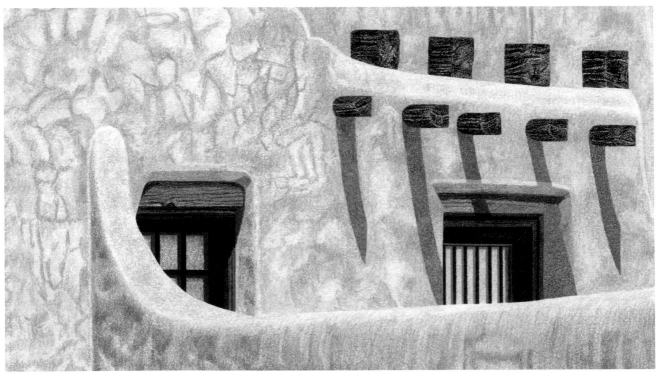

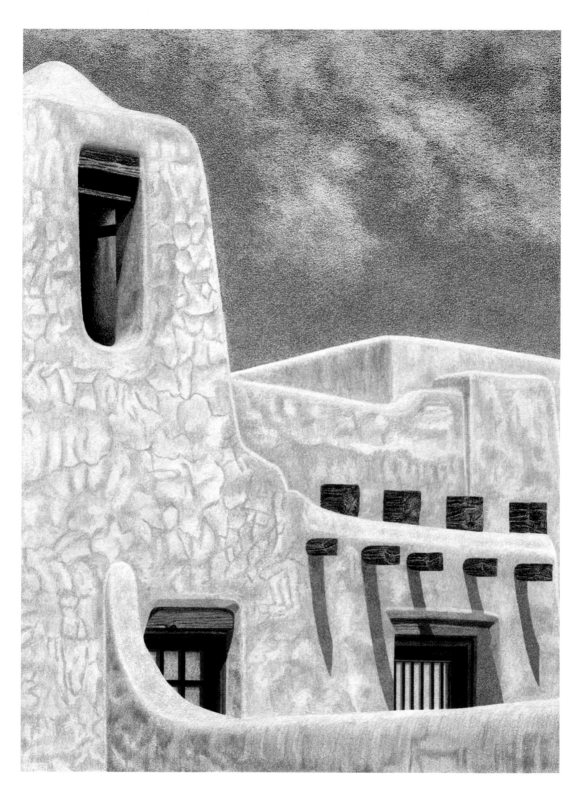

6 Paint the Sky

With a constantly sharpened point, apply Copenhagen Blue and True Blue. To depict the clouds, lift (do not erase) random areas with a kneaded eraser.

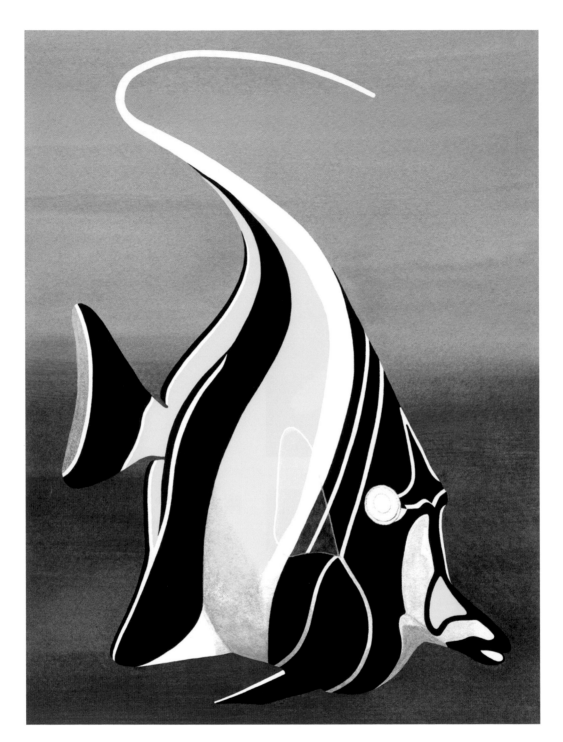

4 Paint the Body

Place equal-length cores of Black and Dark Sepia together in a watercolor palette well, a core of Cadmium Yellow in another, and a core of Cold Gray III twice the length of a Cold Gray II together in a third. Add water and apply colors separately as shown with a medium, round brush and a small round brush. Leave the paper bare for the white areas.

 With the small brush, apply a diluted wash of Azurite Blue and Turquoise to the edge of the tail fin; apply the Black and Dark Sepia mix and Cadmium Yellow to the body area behind the pectoral fin.

 Tighten the edges with dry Black and Canary Yellow Verithins.

5 | Finish the Details

For the eye, using a small brush, paint the outer shadow and pupil with Black and the outer ring with diluted Black. Leave a spot of bare paper for the eye highlight.

For the mouth, apply Alizarin Crimson and Pink Madder Lake to a separate piece of watercolor paper. Add water with a small round brush, and apply to the mouth as shown.

Draw fin details with a Warm Grey 20% Verithin.

SOLVENT WITH LIGHTER FLUID AND DRY COLORED PENCIL TECHNIQUES
Toucan

▨ For this colorful study, lighter fluid was chosen as the solvent because of its smooth blending characteristics and relatively fast drying time. To ensure success, keep the applicator (brush) on the dry side by wiping it dry on a paper towel between applications of colors.

Reference photo

Drawn layout

TOOLS & MATERIALS

SURFACE
Strathmore Series 500 bristol vellum 3-ply, regular surface

SUPPLIES
Ronsonol Lighter Fluid
Small glass container
Small synthetic flat watercolor brush
Paper towels
Cotton-tipped applicators
Cotton-tipped makeup applicators

COLOR PALETTE
Prismacolor Premier:
901 Indigo Blue ▪ 903 True Blue ▪ 905 Aquamarine ▪ 906 Copenhagen Blue ▪ 907 Peacock Green ▪ 908 Dark Green ▪ 909 Grass Green ▪ 912 Apple Green ▪ 913 Spring Green ▪ 916 Canary Yellow ▪ 919 Non-Photo Blue ▪ 922 Poppy Red ▪ 923 Scarlet Lake ▪ 925 Crimson Lake • 935 Black ▪ 937 Tuscan Red ▪ 941 Light Umber ▪ 989 Chartreuse ▪ 992 Light Aqua ▪ 1002 Yellowed Orange ▪ 1003 Spanish Orange ▪ 1004 Yellow Chartreuse ▪ 1069 French Grey 20%
Faber-Castell Polychromos:
108 Dark Cadmium Yellow ▪ 183 Light Yellow Ochre ▪ 186 Terracotta

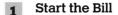

1 Start the Bill

Gradually apply these colors to the following areas approximately as shown, until the paper is almost completely covered:

Red area: Tuscan Red, Crimson Lake, Scarlet Lake and Poppy Red (leave the highlight free of color)

Area adjacent to the red, at the upper portion of the bill: Terracotta, Yellowed Orange and Spanish Orange

Center of the bill: Yellowed Orange, Spanish Orange and Canary Yellow

Remainder of the upper bill: Light Yellow Ochre, Grass Green, Spring Green, Apple Green, Non-Photo Blue, Chartreuse, Yellow Chartreuse and Canary Yellow

Remainder of the lower bill: Indigo Blue, True Blue, Copenhagen Blue, Aquamarine, Light Aqua, Non-Photo Blue, Peacock Green, Dark Green, Grass Green, Spring Green, Apple Green, Chartreuse, Yellow Chartreuse and Canary Yellow

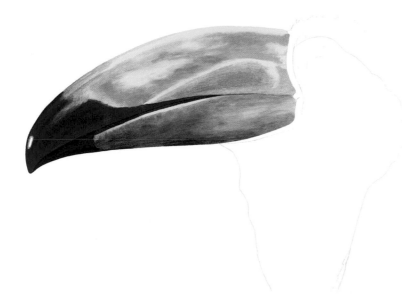

2 Finish the Bill

Apply lighter fluid with a small, synthetic flat brush. Before applying, absorb some of the fluid from the brush in a paper towel. Gently apply to the strongest (darkest) colors first (here, red). When the brush is nearly dry, wipe it thoroughly on the paper towel before dipping it back into the fluid. Leave the highlight at the tip of the beak free of color. Be sure to liquefy the lightest areas (here, yellow) last.

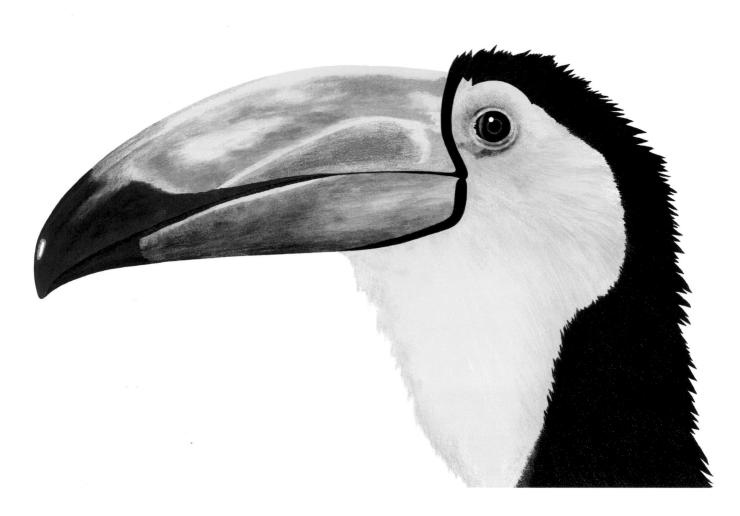

7 Start the Black Feathers

Apply Black using long, linear
strokes that follow the contours
of the subject's feather pattern
until the paper is almost
completely covered.

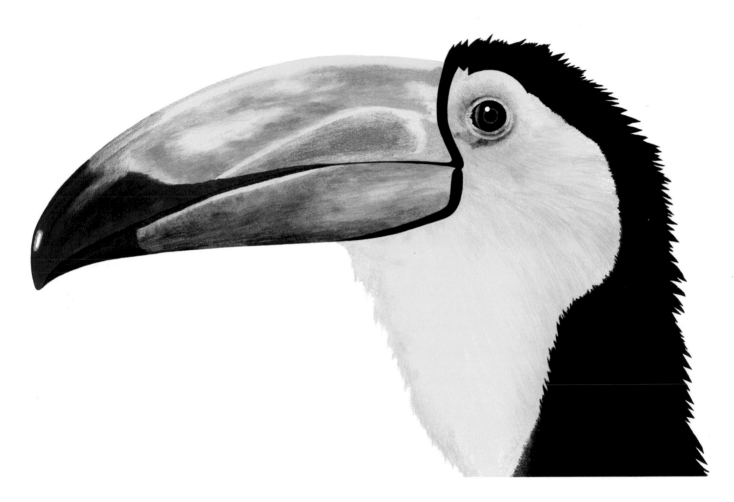

8 Finish the Black Feathers

Apply lighter fluid with the small synthetic flat brush in the same direction as the strokes. Before applying, absorb some of the fluid from the brush in a paper towel.

Index

About the Author

a content + ecommerce company

Other fine North Light Books are available from your favorite bookstore, art supply store or online supplier. Visit our website at fwmedia.com.

20 19 18 17 16 5 4 3 2 1

DISTRIBUTED IN CANADA BY FRASER DIRECT
100 Armstrong Avenue
Georgetown, ON, Canada L7G 5S4
Tel: (905) 877-4411
DISTRIBUTED IN THE U.K. AND EUROPE
BY F&W MEDIA INTERNATIONAL LTD
Brunel House, Forde Close, Newton Abbot, TQ12 4PU, UK
Tel: (+44) 1626 323200; Fax: (+44) 1626 323319
E-mail: enquiries@fwmedia.com

DISTRIBUTED IN AUSTRALIA BY CAPRICORN LINK
P.O. Box 704, S. Windsor NSW, 2756 Australia
Tel: (02) 4560-1600; Fax: (02) 4577 5288
E-mail: books@capricornlink.com.au

ISBN 978-1-4403-3837-3

Edited by Kristy Conlin and Stefanie Laufersweiler
Production coordinated by Jennifer Bass
Designed by Elyse Schwanke

METRIC CONVERSION CHART

TO CONVERT	TO	MULTIPLY BY
Inches	Centimeters	2.54
Centimeters	Inches	0.4
Feet	Centimeters	30.5
Centimeters	Feet	0.03
Yards	Meters	0.9
Meters	Yards	1.1

In addition to being an accomplished fine artist, Gary Greene has been an art director, graphic designer, technical illustrator and professional photographer since 1967. He is the author of eleven North Light Books and eight full-length colored pencil video workshops. He has been a contributor to **The Artist's Magazine**, and his colored pencil paintings have appeared in numerous other publications. Gary has taught colored pencil and photography workshops nationally and internationally since 1985 and conducts online workshops for the Artist's Network. He is a fifteen-year Signature Member of the Colored Pencil Society of America (CPSA). Gary's colored pencil art and photography have won numerous awards, including The Artist's Magazine's National Art Competition and the Colyer-Weston Art League National Art Merit Competition. His work is included in many private and corporate collections.

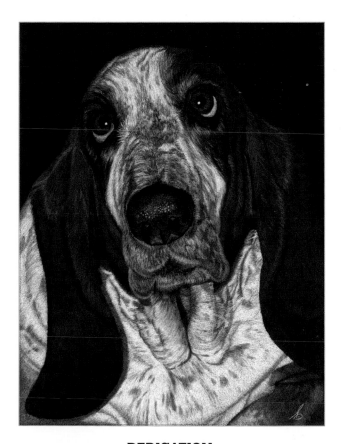

DEDICATION:
IN LOVING MEMORY OF GRRTRUDE.